# H⊕SPITALS

# *of* LONDON

Veronika *&* Fred Chambers
*&* Rob Higgins

AMBERLEY

*This book is dedicated to the staff of the NHS, who provided the will and energy to change bricks and stone into centres of healing.*

First published 2014

Amberley Publishing
The Hill, Stroud
Gloucestershire, GL5 4EP

www.amberley-books.com

Copyright © Veronika & Fred Chambers & Rob Higgins, 2014

The right of Veronika & Fred Chambers & Rob Higgins to be identified as the Authors of this work has been asserted in accordance with the Copyrights, Designs and Patents Act 1988.

ISBN 978 1 4456 3809 6 (print)
ISBN 978 1 4456 3827 0 (ebook)

British Library Cataloguing in Publication Data.
A catalogue record for this book is available from the British Library.

Typesetting by Amberley Publishing.
Printed in the UK.

# Contents

# Introduction

While much has been written about the structure and organisation of health care in London, less attention has been paid to the histories of the hospitals themselves. The hospitals of London not only reflect the social and political history of the city, but also hold centre stage in the history of medicine. Many innovations and discoveries were made in them and many specialist hospitals were the first of their type in the world, developing instruments and treatments that are the basis of modern medical practice.

Today, hospitals are fairly easy to categorise, being either very large and super-specialist or small with limited services – a system that evolved from a huge range of types and providers. It has not been possible to include all the hospitals of London in this small book (there were hundreds), but the examples here illustrate the scale and variety of institutions offering health care both before and after the introduction of the National Health Service in 1948.

Advances in medicine and surgery (initially without anaesthesia or antisepsis) led to the creation of voluntary hospitals funded by donations and subscriptions. Several of these became the great teaching hospitals of London, with allied medical schools. The foundation of the National Health Service in 1948 is rightly regarded as a defining evolution in British health care, but the state had always provided a substantial share. Its involvement expanded progressively, initially through workhouses, built to house the destitute poor – although some resembled large country houses that belied the experience of the inmates. It was common to share beds, and infectious disease outbreaks were fuelled by a combination of malnutrition, poor sanitation and overcrowding. Over time the mentally ill, the mentally deficient and epileptics were removed from workhouses and placed in asylums, leaving behind the chronically ill, aged and infirm.

Gone, and almost forgotten, are the huge resources required to care for the injured of the two World Wars. While the dead of the First World War are remembered, there were nearly ten times as many injured, and from 1914 to 1918 there were over 300 temporary hospitals in London alone. The Emergency Medical Service during the Second World War faced a different problem – air-raids and civilian injuries. Bomb and missile attacks on London necessitated mass evacuations of London hospitals. A number of the wooden EMS ward huts built outside central London remain in use today.

Smallpox and fever hospitals exist no more. The epidemics that afflicted the city have disappeared and today infectious diseases have largely been tamed by vaccination and antibiotics. Tuberculosis, once feared, also became treatable (although it is now becoming drug resistant).

The history of London's hospitals in the second half of the twentieth century has been characterised by profound changes in the political climate and by the patterns of illness in communities. Attitudes to illness have also changed, most obviously in the mental services. The large asylums have all closed. Several have metamorphosed into luxury private

accommodation, in some cases remaining walled communities – although now to keep undesirables out, not the inmates within.

The National Health Service attempted to coordinate healthcare across the nation. However, great success in delivering groundbreaking therapies has been matched by a difficult modern political environment, where the motives of politicians and health care professionals are treated (not without good reason) with great suspicion on both sides. The length of hospital stays and the number of hospital beds have fallen dramatically, while new complex treatments and investigations demand progressive centralisation of hospital care. New problems are emerging. The increase in 'lifestyle disorders', such as obesity, diabetes and substance abuse, and chronic conditions, particularly of old age, are placing new demands on the hospital system. The resistance to antibiotics has made hospital-acquired infections part of modern life, while world travel has brought novel diseases to the UK – a rapidly spreading zoonotic influenza pandemic is always a risk. The contracting out of cleaning and maintenance services, and more, has fragmented the NHS and demotivated its staff. However, the NHS remains the greatest national experiment in universal health care and, as the politician Nigel Lawson remarked, the nearest thing the English have to a religion.

# Healthcare in London Before the NHS

In the Middle Ages, care of the sick and infirm was mainly provided by the church, in particular monasteries, which were dissolved by Henry VIII in 1546; St Bartholomew's Hospital was the only survivor (*see p. 34*). From the seventeenth century, the state began to accept responsibility for the 'impotent' poor (the old, the blind or lame, etc.) under the provision of the 1601 Poor Relief Act (the 'Old Poor Law'). Thus, for the inmates of the City of London workhouse '… in case of Sickness, broken Limbs, or Sores, or Wounds, they have Advice, Physik and Surgery gratis'. However, the implementation and enforcement of this Act was haphazard, and no coherent hospital system was established.

## VOLUNTARY HOSPITALS (1720–1948)

Hospitals that would be recognisable as such today were first established in the early eighteenth century as charities to look after the sick poor. Many had their origins in dispensaries, providing outpatient care; others were established in converted private houses with a few beds. When finances allowed, they moved into larger purpose-built premises. As Britain became one of the wealthiest nations in the world during the Industrial Revolution, voluntary hospitals flourished. Those in central London became teaching hospitals and centres of scientific research (*see chapters 3 and 4*).

By the mid-nineteenth century, the 'pavilion' plan for new hospitals had become popular, with the main ward blocks (pavilions) linked to the central administration building by

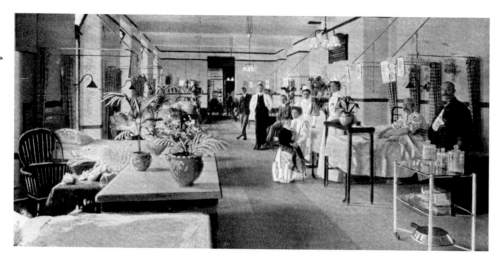

Fig. 1: A Nightingale ward in the London Hospital.

corridors (*see St Thomas' Hospital, p. 37*). The long wards were sometimes known as Nightingale wards, named after Florence Nightingale, a prominent campaigner for better hygiene and healthcare.

Most patients admitted to these hospitals had acute disease; those with cancer or incurable afflictions were excluded. Operations were performed relatively rarely until the introduction of anaesthesia (1847) and antisepsis (1867) enabled improvement in surgical treatment. As medical advances were made, hospital design became increasingly complex to include new technologies, such as X-ray machines (after 1896).

**Convalescent homes:** In the mid-nineteenth century, it was recognised that patients need not remain in acute beds following treatment, but could convalesce in surroundings that provided a degree of nursing care. Many hospitals established their own convalescent homes in the countryside or at the coast, thus freeing up beds in overcrowded wards.

**Cottage hospitals** (village hospitals) provided immediate treatment for local patients who would otherwise face a journey to the nearest hospital. Although they had existed before, the cottage hospital movement began to gather pace in the 1860s. Such hospitals proved very popular and were supported by the local population. Their size varied – some could be small and homelike with only four beds and a live-in nurse. Most had a small dispensary and an operating theatre. Later, successful cottage hospitals were built to a larger scale.

**Hospitals for Foreign Nationals and Faith Groups:** The first hospital for poor foreigners in London was the French Protestant Hospital established in 1708 by the Huguenots in Victoria Park. A German hospital, an Italian hospital and another French hospital were established later. Jewish hospitals opened in the East End of London, while various Catholic convents provided nursing care for convalescing patients or the terminally ill.

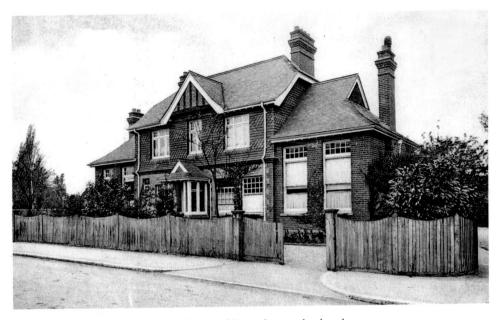

Fig. 2: Carshalton Cottage Hospital, resembling a large suburban house.

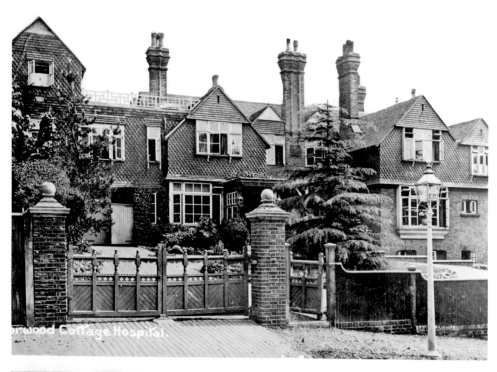

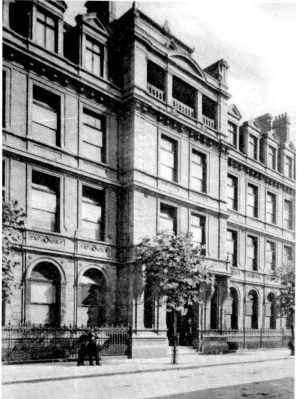

*Above:* Fig. 3: Norwood Cottage Hospital – a more mansion-like structure.

*Left:* Fig. 4: The French Hospital was established in 1867. It moved to Shaftesbury Avenue in 1900. When it joined the NHS in 1967, it became the Shaftesbury Hospital, specialising in renal disease. It closed in 1992 and the building is now the Covent Garden Hotel.

**Specialist Hospitals** (*see chapter 4*): The first was the London Lock Hospital, which opened in 1786 and treated patients with skin (i.e. venereal) disease (such patients were excluded from voluntary general hospitals because they were deemed to have sinned). As the nineteenth century progressed, other specialist hospitals began to appear. By 1869, there were sixty-four in London.

**Maternity Hospitals:** The earliest example in London was the British Lying-In Hospital in 1747. Many closed as their rates of puerperal fever (an often fatal bacterial blood infection after childbirth) were much higher than in general hospitals. One of the most successful was Queen Charlotte's Maternity Hospital. The Maternity and Child Welfare Act 1918 required local authorities to provide maternity facilities in homes or hospitals.

## Funding for Voluntary Hospitals

By the end of the nineteenth century, finances were precarious at many voluntary hospitals. They ran publicity campaigns and appeals for donations, and the sources of funding became more diverse.

Two philanthropists who donated large sums of money deserve special mention: Siegfried Rudolf Zunz, who provided funds for wards in London hospitals to be named after his beloved wife, Annie, and John Passmore Edwards, the Cornish businessman and philanthropist who gave financial support to several small hospitals.

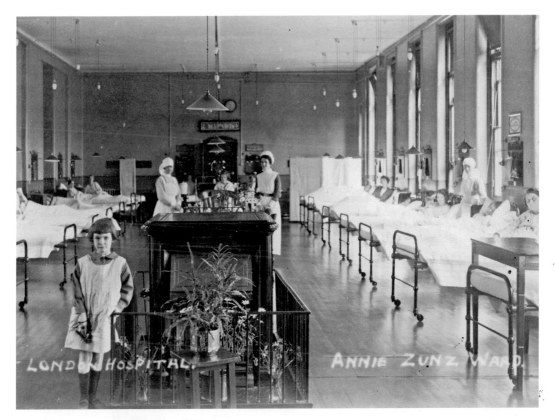

Fig. 5: The Annie Zunz ward at the West London Hospital.

Fig. 6: The Passmore Edwards Hospital for Hornsey, Wood Green and Southgate opened in 1895. It had been built almost entirely with the financial support of John Passmore Edwards who also funded the building of several other hospitals. It joined the NHS as the Wood Green and Southgate Hospital, closing in 1983.

*Right:* Fig. 7: 'Toby' raises funds for the Woolwich & District War Memorial Hospital.

*Below:* Fig. 8: A fundraising carnival in July 1907 in support of the East Ham Hospital, another project financially supported by John Passmore Edwards. It was extended in 1915, when it was renamed the Passmore Edwards East Ham Hospital. The hospital was rebuilt in 1929 and renamed the East Ham Memorial Hospital in memory of the local servicemen killed in World War One. It is still in health care use today.

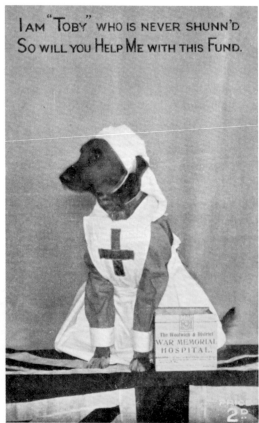

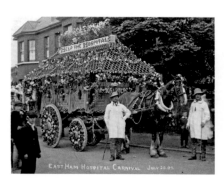

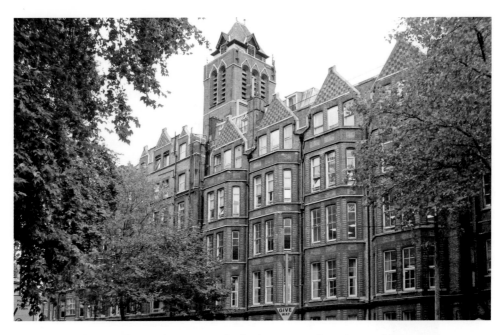

Fig. 9: One of the earliest infirmaries to be built separate from its workhouse is the current South Wing of St Pancras Hospital. The central tower is about four storeys higher than the five-storey building.

## WORKHOUSE INFIRMARIES (POOR LAW HOSPITALS) (1834–1930)

Following the Poor Law Amendment Act 1834, parishes throughout Britain were grouped together to form unions; each built a workhouse in its area to accommodate the destitute poor. The original infirmaries were rooms in workhouses, usually with no heating and little furniture. As well as physically ill paupers, the mentally ill and mentally handicapped were also admitted – they had nowhere else to go. Workhouses gradually filled up with the chronic sick and mentally ill. Patients were cared for by their fellow inmates, untrained in nursing skills and usually aged fifty or over. Workhouses had substantial maternity wards, but because of the social stigma of being a pauper, only the street address was given on birth certificates for children born in them. Separate buildings for workhouses and infirmaries began to be built around 1867. Poor Law infirmaries gradually improved and by 1900 patients preferred the better standard of care provided in them.

## MENTAL HOSPITALS (1845–1990s)

For centuries, mental illness was regarded as a spiritual affliction rather than a pathological one. Mentally ill patients were removed from society and 'contained' in asylums. The earliest was Bethlem, which opened in 1678 in a grand building in the City of London (now demolished). Most eighteenth-century asylums resembled country houses and were privately run. The Lunatic Asylums Act 1845 compelled the counties to build lunatic asylums for their mentally ill paupers (*see chapter* 9).

# MILITARY HOSPITALS (1865–1977)

Military hospitals in the modern sense of the word did not appear before the eighteenth century. 'Hospitals' for retired or disabled sailors and soldiers had been established at Greenwich and Chelsea respectively in the second half of the seventeenth century. They were built in a grand style.

The Royal Herbert Hospital (1865), built in Woolwich for the army, was the first London hospital for sick and injured servicemen. The Queen Alexandra Military Hospital on Millbank (1905) was one of the last to be built.

During the two World Wars, several London hospitals and county mental asylums became, in part or in full, military hospitals, as did many large houses and buildings. In the First World War, they were used for injured servicemen and, in the Second World War, for injured civilians. Many temporary hutted hospital wards were built during both wars.

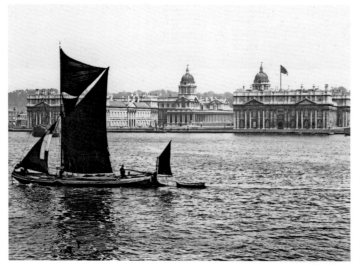

Fig. 10: The Royal Hospital for Seamen at Greenwich was designed by Christopher Wren and was four times the size of the Royal Hospital, Chelsea, with room for 2,044 pensioners. It closed in 1869 and became the Royal Naval College. The Grade I listed buildings are now a heritage site and open to the public.

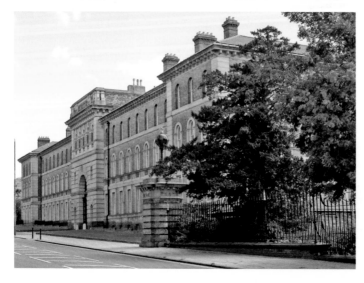

Fig. 11: The Royal Herbert Hospital closed in 1977. The buildings were converted into luxury apartment blocks – the Royal Herbert Pavilions.

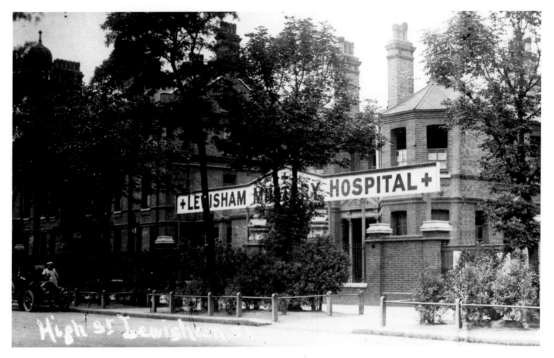

Fig. 12: During the First World War, the inmates of the Lewisham workhouse were transferred elsewhere and it became the Lewisham Military Hospital. It had twenty-four beds for officers and 838 for servicemen. Some 190 beds were for German POW, including twelve for insane officers. Today it is the University Hospital Lewisham.

## THE METROPOLITAN ASYLUMS BOARD (1867–1930)

With a view that London health care could become economical if provided by a large-scale organisation, the government enacted the Metropolitan Poor Act in 1867. All the facilities of the unions and parishes in London were subsumed into the Metropolitan Asylums District, managed by the Metropolitan Asylums Board (MAB), a new central body to provide the first organised hospital system for the poor. The board's initial responsibility was to establish accommodation for fever and smallpox patients, certain types of mental cases, and sick children.

**Isolation (Infectious Diseases) Hospitals:** The first voluntary isolation hospital for smallpox and infectious diseases opened in 1802 (eventually becoming the London Fever Hospital).Under the auspices of MAB, another six smallpox and fever hospitals, designed as paired buildings, were built. The fever hospitals cared for patients with scarlet fever, diphtheria, enteric fever (typhoid), typhus, measles, whooping cough, cholera and dysentery.

In 1881, the Royal Commission recommended that fever hospitals be freed from the Poor Law, and smallpox patients be transferred to a less urban site. From 1883, smallpox patients were transported by the River Ambulance Service to hospital ships moored at Long Reach, near Dartford (*see p. 88*). Only paupers were admitted to MAB institutions until 1891, when fever hospitals became free to all.

Fig. 13: The Park Fever Hospital at Hither Green was the largest fever hospital in England when it was built in 1897, with 548 beds and a staff of 3,000. In 1910, it became a children's convalescent hospital. It joined the NHS and was renamed Hither Green Hospital. It closed in 1997, a century after it opened. The site is now a housing complex; some original buildings survive.

**Tuberculosis Sanatoria:** The first purpose-built sanatorium for the treatment of consumption (pulmonary tuberculosis) was the Brompton Hospital in 1854. Tuberculosis (TB) was one of the great killers of the nineteenth century, but was not identified as an infectious disease until 1865. There was no cure; treatment consisted mainly of fresh air and bed rest. The National Insurance Act 1911 entitled working men to receive free treatment.

The disease was particularly prevalent amongst the poor, and MAB became responsible for the care of TB patients in 1912. It was not until the Public Health (Tuberculosis) Act 1921 that local authorities began to build sanatoria in large numbers. By this time, X-ray diagnosis and surgical intervention (plombage, a method to collapse part of the lung artificially, so 'resting' it) was commonplace. The need for sanatoria declined during the 1950s when new drugs proved remarkably effective against the disease.

**Mental Deficiency Asylums:** Until 1870, when MAB opened two asylums (one at Leavesden for north Londoners [see p. 122] and one at Caterham for south Londoners), these patients had been cared for in small, often private, homes. The new asylums established a trend in accommodating several hundred inmates in a single institution.

Patients were graded according to their ability to be trained for some kind of occupation. Higher-grade mentally deficient patients learned a trade, while lower-grade ones helped with domestic and laundry work. The Mental Deficiency Act 1913 established four grades of mental deficiency: the most seriously affected were 'idiots'; the second group

Fig. 14: Mount Vernon Hospital in Hampstead was one of many private sanatoria established in the nineteenth century.

were 'imbeciles'. The third were 'feeble-minded persons' or 'morons' who required care, supervision and control for their own protection. 'Moral imbeciles' had some permanent mental deficiency with a strong vicious or criminal propensity on which punishment had little or no deterrent effect. Unmarried mothers were included in this group (the Act gave local authorities the power to place people having sex outside marriage into institutions). Homosexuals and transgender people were also included.

**Children's Hospitals:** In 1897, MAB acquired new responsibilities to provide health care for pauper children suffering from eye, skin or scalp disease, the chronically sick requiring long-term nursing, and convalescents. Hospital schools for long-stay patients and sanatoria were established in the countryside and by the sea. In 1909, the new fever hospital built at Carshalton became instead the Queen Mary's Hospital for Children. Mainly those with non-pulmonary tuberculosis and rheumatic fever (a condition that affected the joints but also led to often fatal heart disease) were admitted.

Fig. 15: Queen Mary's Hospital for Children had 1,000 beds. The young patients were accommodated in single-storey ward blocks or 'cottages', which were arranged in pairs. The administrative block (*above*) was at the north of the site. The hospital closed in 1993.

**Epileptic Colonies:** Colonies for epileptics were first established in the late nineteenth century; Chalfont St Peter was the earliest and was funded by John Passmore Edwards. The Mental Deficiency Act 1913 required local authorities to make provision for these patients. MAB instituted two colonies – one at Edmonton for 355 male patients in 1915, and one in Brentwood for 350 female patients in 1916. Both provided occupations, such as horticulture, gardening and pig rearing, along with industrial activities, such as printing, carpentry, knitting and domestic and laundry work. At Edmonton the boys had boxing lessons, and at Brentwood the girls had dancing.

**Venereal Disease Hospitals for Females:** In 1919, following ministerial concern about the rising numbers of women with venereal disease (VD), MAB established a hospital in Sheffield Street (*see p. 50*). Demand for beds diminished with the introduction of sulphonamide drugs and penicillin.

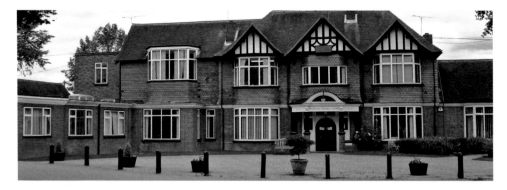

Fig. 16: Passmore Edwards House was built in 1904 as the administration building for the Chalfont Epileptic Colony (now renamed the Chalfont Centre for Epilepsy).

## MUNICIPAL HOSPITALS (1890–1948)

Following the Local Government Act 1888, the County of London came into being in 1889, formed from much of Middlesex and parts of Surrey and Kent. The Lunacy Act of 1890 required it to provide and maintain mental hospitals for rate-aided patients.

**Mental Hospitals** (*see chapter 9*): The London County Council (LCC) took over responsibility for the pauper lunatics in the new county. It inherited three asylums from the County of Middlesex, as well as plans for the yet unbuilt Claybury Asylum and, from the County of Surrey, the recently built Cane Hill Asylum. These four asylums were already overcrowded and contained 10,000 inmates, with another 5,000 accommodated in other local authorities' institutions. Claybury Asylum was built in 1893 and was considered a great advance in design, but its huge cost caused a lowering of building standards for the LCC's second asylum at Bexley (1898). By 1924, twelve more asylums had opened.

**Isolation Hospitals:** The Isolation Hospitals Act 1893 had county councils build isolation hospitals or compel their local authorities to do so. The hospitals typically comprised parallel rows of detached ward blocks linked by a covered walkway.

## REORGANISATION OF HEALTH CARE PROVISION (1929–30)

In 1928, the government reorganised local government in England and Wales. Poor Law Unions were abolished under the Local Government Act 1929, and their functions transferred to the counties and county borough councils. On 1 April 1930, following the dissolution of MAB, the LCC took over administrative control of its seventy-seven hospitals (with a total of 40,000 beds) and its five mental deficiency asylums, giving the council a total of ninety-eight hospitals with 71,771 beds.

## THE EMERGENCY MEDICAL SERVICE (EMS) (1939–45)

As war loomed in the summer of 1939, the Ministry of Health had no idea of how many hospital beds were available and no means of finding out. The authorities estimated that some 100,000 tons of bombs would be dropped on London in the first fortnight of war. A quarter of a million casualties were anticipated and contingency plans were made to organise sufficient medical care.

London was divided into ten pie-shaped sectors. Each had its apex on the one of large teaching hospitals, whose patients were evacuated so that the expected casualties could receive treatment. Each sector was run from a peripheral base hospital several miles outside London.

During the Second World War, ten hospitals had to be evacuated completely because of bomb damage. Some 4,456 beds were destroyed by enemy action, 578 of these in mental hospitals.

# THE POST-WAR SITUATION

After the war, inpatient care continued to be provided by a mixture of private nursing homes and the voluntary and state-funded hospitals, but there was a great ambition to create a better and more equal society. The time seemed right to nationalise industries and services essential to the functioning of the nation. The drive for a unified health service came not just from an egalitarian or socialist ideal, but also from the needs of the middle and 'deserving' working classes who were unable to afford medical care.

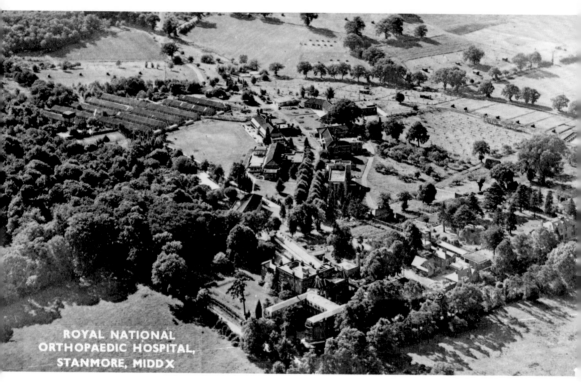

Fig. 17: At the outbreak of the Second World War in 1939, when the Royal National Orthopaedic Hospital had 276 beds, it joined the EMS. The building of ten prefabricated huts (shown at the top left of the image) to accommodate expected air-raid casualties began in October 1939 and was completed the following autumn. A covered walkway, nicknamed 'The Slope', was built to connect the huts together (it was later provided with side walls). The huts became known as the Slope Wards. They are still in use today (2014).

# Chapter 2

# The National Health Service

A vision of a national health service to deliver free health care to all had grown between the wars. The Labour politician Aneurin Bevan led the drive to establish the NHS after the Second World War, inspiring the population while assuaging the medical profession, who mostly deeply opposed its formation. At the inception of the service on 5 July 1948 (the 'Appointed Day'), almost all the health-related facilities of local authorities, voluntary bodies and charities were transferred to the control vested in the Minister of Health. However, there were exceptions.

**Disclaimed Hospitals**
Under the terms of the 1946 NHS Act, which established the service, the governing body of a hospital that wished to remain outside the NHS could apply to the minister to be exempted. The decision was entirely at the discretion of the minister, and hospitals so exempted were referred to as 'disclaimed'.

They were mostly, but not exclusively, of charitable – particularly religious – foundation, who believed the type and level of care they provided would be compromised by becoming embedded in the larger service.

Fig. 18: The British Home and Hospital for Incurables was founded in 1861 as a home for disabled middle-class patients. It opened its current building on Crown Lane in 1894. It was disclaimed from the NHS and remains an active and independent charitable institution.

## Organisation of Hospitals in the London Area

The London area was divided into four geographical segments – the North-West, North-East, South-East and South-West – each with its own Metropolitan Regional Hospital Board. Hospitals came under Hospital Management Committees, who were responsible to the regional boards, while teaching hospitals each had their own Board of Governors.

The Regional Hospital Boards inherited a wealth of hospital buildings of varying sizes, most dating from the nineteenth century. After six years of war, these were dilapidated and bomb-damaged, but a nationwide shortage of building materials made repair difficult. Severe nursing shortages resulted in ward closures.

## The Early Years of the NHS

Benefitting most from the NHS were the middle classes, who had been excluded from panel doctors (the equivalent of general practitioners), as only lower paid workers were covered by the compulsory National Insurance scheme for free medical care. The first decade saw a surge of patients with long-standing illnesses previously unable to afford treatment. Demand soon outstretched the budget and, in 1951, charges for prescriptions and for dental treatment (mainly dentures) had to be introduced.

The development of antibiotics (sulphonamide drugs in 1935, penicillin during the Second World War and streptomycin in 1947) had enabled the cure of infectious diseases, but the drugs were not yet widely available and acute patients remained in hospital on average for around eighteen to twenty-one days. Bed rest was the main form of treatment for tuberculosis and for other conditions such as ulcers and heart attacks. Childbirth usually involved a two-week stay in hospital.

Following successful vaccination programmes, infectious disease epidemics, such as diphtheria and scarlet fever, became less important, but in the 1950s a new terror emerged

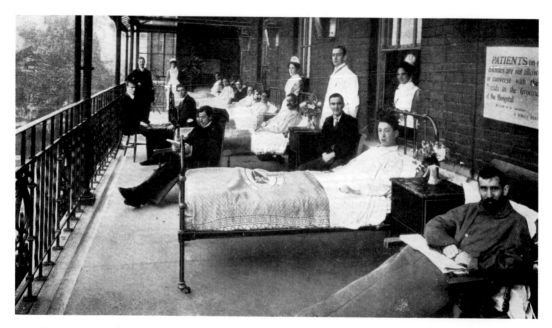

Fig. 19: One of the balconies of the City of London Hospital (later renamed London Chest Hospital). Patients with 'consumption' (TB) were exposed to fresh air as much as possible.

– polio. Between 1947 and 1958, the disease disabled over 30,000 people in Britain. The injectable Salk vaccine became available in 1955 (the oral sugar cube Sabin vaccine appeared in 1962), and school children were quickly immunised. However, existing polio victims required hospitalisation, and special wards were established for them, where 'iron lungs' (mechanical ventilators) enabled severely affected cases to breathe.

## The First 'Casualties' – Isolation Hospitals and TB Sanatoria

As antibiotics became more widely available, the need for special infectious disease hospitals diminished. Many closed and were demolished, but a few were adapted to accommodate chronically sick elderly patients.

Treatments for pulmonary tuberculosis, both medical and surgical, had vastly improved. The disease could be treated with combinations of new drugs, thus supplanting the traditional regime of prolonged bed rest, nutritious food and fresh air. As living conditions improved, the disease became less prevalent and by the end of the 1950s, was no longer a serious public health threat. TB sanatoria also became redundant. Some, like Harefield Hospital (*see p. 60*), reinvented themselves as specialist hospitals for other lung diseases and heart conditions; others closed.

## The Building of New Hospitals

In 1961, the Minister of Health, Enoch Powell, produced the Hospital Plan, which recommended services should be centralised in large district general hospitals. The plan proposed a massive nationwide building programme of ninety-nine new hospitals (and 134 upgraded) over the next decade. The estimated cost of £500 million turned out to be a gross

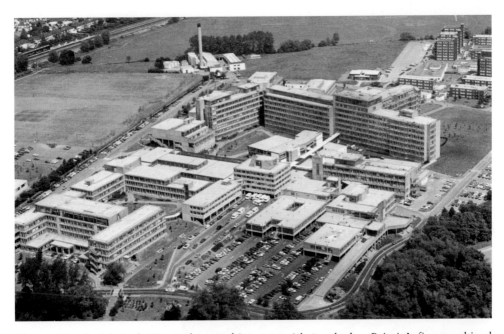

Fig. 20: Northwick Park Hospital opened in 1970 with 800 beds – Britain's first combined District General Hospital and Medical Research Centre. It was also the first example of 'indeterminate architecture', in which no attempt is made to construct a finite form. Buildings were added on as necessary.

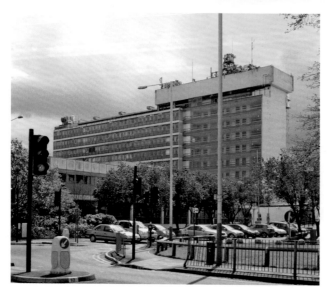

*Top:* Fig. 21: Newham University Hospital was built in the nucleus style.

*Middle & Left:* Fig. 22 A&B: Hillingdon Hospital enjoys a plethora of architectural styles. The ward tower block surrounded by low-level buildings was built in the 1960s, but the wooden EMS huts built in 1940 are still in use today (2014).

underestimation and the plan was drastically cut back in 1966; only a third of the projected schemes were ever completed.

The 800-bed Greenwich District Hospital was one of the first to be built by the newly formed Hospital Design Unit of the Ministry of Health. Many units were prefabricated in the factory and assembled on site. Built in three phases, it was completed in 1972. The new fully air-conditioned building was not without its problems and the hospital closed in 2001. It was demolished in 2006, a sadly short lifespan (hospital buildings are normally expected to last for at least 100 years).

Under the Nucleus Planning System, which prevailed for the next fifteen years, the first phase of the new hospital (the nucleus of the service) could be extended in later phases to supplement facilities. A common criticism of them was that, while the facilities and space for patients was ample, for staff they were not.

Despite government desire to standardise hospital construction, most new hospitals remained one-off designs. Many followed the fashion for tower blocks on a surrounding podium – the 'matchbox on a muffin'. However, as new hospitals were expensive, older ones, such as the Nelson Hospital (*see p. 106*), were rearranged internally and converted to new purposes.

## Advances in Healthcare

By the 1960s, surgical techniques had greatly improved and many new treatments were available, including renal dialysis and organ transplantation. Chemotherapy improved survival rates for cancers. More patients could be treated in more complex ways and health

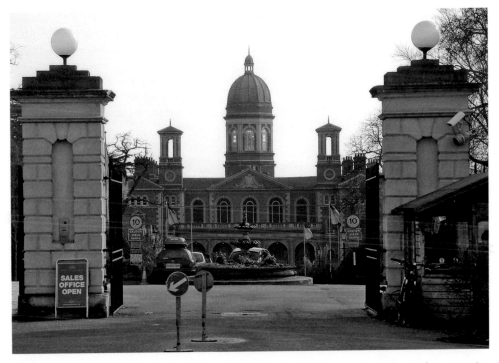

Fig. 23: The former Friern Hospital is now Princess Park Manor – a luxury gated community containing 256 apartments, a gym and a swimming pool, set in 30 acres of parkland. The historic front gates, kept open while the hospital existed, are now kept firmly closed.

care became increasingly expensive. The 1967 Abortion Act led to a greater than expected demand for services, while ironically the survival of premature babies improved.

During the 1970s, new imaging techniques were becoming available. X-rays had been central to diagnosis since the 1930s, but computers enabled the development of computed tomography (CT). By the end of the decade, CT scanners could produce three-dimensional images of any part of the body. Ultrasound was commonly used, especially in maternity units. The use of radioactive isotopes enabled positron emission tomography (PET) to demonstrate where cells were particularly active; a new department – the Nuclear Medicine Department – was required to house the scanners. Magnetic Resonance Imaging (MRI), an investigative technique not involving X-radiation, began to be introduced in the early 1980s, but few hospitals could afford these expensive devices.

Rising expectation of its services, and an increasingly elderly population requiring more medical help, was putting a great strain on the NHS. Economies of scale resulted in services being concentrated in larger hospitals. Smaller hospitals began to close, despite vociferous protests from the local population. This led to a policy of 'closure by stealth', removing departments one at a time from a smaller hospital, until there could be no argument that the services were no longer viable as a whole.

## Care in the Community

Enoch Powell had been the first to mention 'care in the community' in a speech he gave in 1961, when he suggested that large hospitals for the mentally ill and mentally deficient were more like prisons, preventing a return to normal life; society's attitudes towards these patients needed to change.

Treatments for mental conditions used during the 1930s and 1940s had included lobotomy, insulin coma and electro-convulsive therapy (ECT). By the 1950s, psychiatric services had become established. Largactil replaced lobotomy and the introduction of other psychotropic drugs in the 1960s enabled the mentally ill to be treated as outpatients.

During the 1970s, as district general hospitals began to establish psychiatric departments, wards began to close in the large mental hospitals (*see chapter 9*). By 1975, the number of beds had halved. Scandals of the conditions in hospitals for the mentally deficient in the 1980s hastened their end. They had all closed by the 1990s.

## REFORMING THE NHS

The NHS operated for over a twenty-five years in a structure more or less as originally conceived. However, despite progressive improvements in patient care, political pressures on hospitals became dominated by efforts to change their management structure to contain costs.

**1974:** *Top-down rationalisation.* Hospital services were merged with local authority services, under a new structure of fourteen Regional Health Authorities and sixty Area Health Authorities – also including the formerly independent teaching hospitals. District Health Authorities replaced Hospital Management Committees. The organisation chart looked tidier but incorporated many dysfunctional characteristics.

**1975–78:** *A time of strife.* Proposals to reduce private practice for consultants within the NHS created great unease within the medical profession. Galloping national inflation (which reached 26.9 per cent in 1975) and wage restraints led to industrial action by

ancillary workers. Nurses also threatened strike action. Financial problems were worsened by the oil crisis, leading to the 'winter of discontent'.

**1979:** *The situation worsens for London hospitals.* A Resource Allocation Working Party (RAWP) generated a new funding model, based on mortality statistics, which shifted substantial amounts of NHS money to deprived regions, largely at the expense of the London regions (North West England had previously received the least and North-East Thames the most per capita).

**1982:** *Management trumps medicine.* Area Health Authorities were abolished, leaving the Regional Health Authorities in charge of 192 District Health Authorities. Teaching hospitals were grouped under Special Health Authorities. Large general hospitals were favoured, and cottage hospitals and smaller casualty units closed, along with separate maternity hospitals. An increased focus on supporting the elderly and the mentally ill made it even harder to balance the books. Support services began to be outsourced to the private sector.

**1991:** *The Internal Market.* On the principle that, if the NHS could not be privatised, it could be made to behave as if it had been. The NHS was divided into providers (the hospitals now organised as Trusts) and purchasers (the Health Authorities, and GPs who became independent fund holders). Providers would compete, and purchasers could choose among them. A Patients' Charter, intended to hold the ring on all this, proved financially unviable. Public concern was beginning to be expressed about the privatisation of the NHS.

**1992:** *Private Finance Initiatives (PFIs).* By the 1990s, it was clear that many hospital buildings in London were inadequate for the demands of modern healthcare. PFIs were introduced as the preferred procurement method for major government projects using private capital – and remaining off the public balance sheet. Private consortia would design, build and manage new hospitals for the lifetime of the contract, typically thirty years, after which management of the building and services would transfer to the public sector. The customer Trust would be committed to (often onerous) recurring costs far into the future. Trusts in London had by far the biggest burden of repayments; by 2011, these amounted to some £143.9 million each year, almost a quarter of the total in England.

**1996:** *Single Tier Health Authorities.* Another organisation chart replaced the Regions and Districts with ninety-six new single-tier Health Authorities.

As the NHS celebrated its fiftieth anniversary, spending on health care in the UK lagged well behind that of other developed nations and the UK languished at the bottom of European league tables for access to health care. Poor hygiene was brewing a scandal in hospital-acquired infection rates, and waiting times for surgical procedures were a cause of national outrage. On the positive side, most hospital specialities had managed to introduce new technologies, and the outcomes for individual patients had improved markedly. Many of the smaller, out-of-date hospitals had closed, although the investment required to ensure continuity of care when hospitals were closed was often lacking. The nation continued to value the NHS, and public opinion was securely in favour of improving the NHS rather than its replacement.

**2000:** *Primary Care Trusts (PCTs).* These were to plan, fund and coordinate all NHS services in a defined geographical area, including GP surgeries, dental surgeries, mental health services, pharmacists, optometrists, patient transport, screening and walk-in clinics.

**2002:** *Strategic Health Authorities (SHAs).* After just six years, the single-tier Health Authorities were replaced by twenty-eight SHAs, including NHS London.

**2004:** *Foundation NHS Trusts.* Not quite privatised, these were to be independent legal entities, free from central government control, with a Board of Governors made up of staff, patients, members of the public and partner organisations. They aped, but did not truly espouse, the cooperative model. With their financial freedom, they could raise capital and retain financial surpluses to invest in the delivery of new services. At the time of writing (2014) all existing Trusts are meant to aim to become Foundation Trusts.

**2006:** *A contraction of management levels.* From fourteen regions and 192 districts in 1982, to ninety-six Health Authorities in 1996, to twenty-eight Strategic Health Authorities in 2002, this changed to only ten – to save money. The PCTs remained.

**2013:** *Clinical Commissioning Groups (CCGs).* On 30 March, the SHAs and PCTs were dissolved. They were replaced on 1 April by NHS England, and some 200 CCGs.

# Chapter 3

# Undergraduate Teaching Hospitals

The flagship medical establishments in London have always been the teaching hospitals and their associated medical schools – the latter provide theoretical training and dissection, while clinical instruction is given on the hospital wards (it was not until the 1870s that the Royal Free Hospital became the first teaching hospital in Britain to allow female medical students on its wards). Medical training became more standardised after 1858, when the General Medical Council was founded, but the schools and their associated hospitals remained separate institutions, stoutly independent of each other and often with different agendas.

At the beginning of the Second World War in 1939, each teaching hospital was assigned a sector under the Emergency Medical Service (EMS). The parent hospitals became primary casualty receiving centres, whence patients were evacuated to base hospitals outside central London (the EMS hutted wards built at these remained in use long after the war had ended).

In 1948, the twelve medical schools in London were not integrated into the NHS but retained their own administrations, while their associated undergraduate teaching hospitals kept their Boards of Governors (non-teaching hospitals were managed by Hospital Management Committees). In 1974, following a major reorganisation of the NHS, the hospitals lost their separate funding and the independence provided by their Boards of Governors, coming under the control of a District Health Authority (Teaching), part of the local Area Health Authority. In 1992, the Tomlinson Report called for the amalgamation of eight medical schools and the closure of four teaching hospitals. By the end of the decade, several undergraduate and postgraduate hospitals had merged, as had several medical schools.

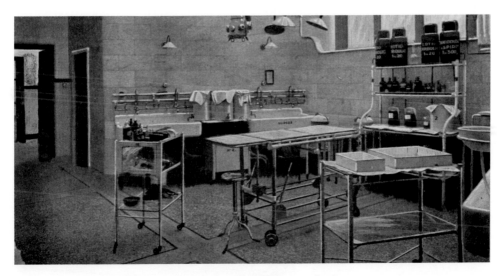

Fig. 24: An operating theatre at the London Hospital, now obsolete.

# Charing Cross Hospital
## Agar Street, West Strand, WC2N 4JP

Fig. 25: The building in 2007.

The West London Infirmary & Dispensary was founded by Dr Benjamin Golding in 1818. In 1823, it moved to larger premises in Villiers Street, where it had twelve beds. It was renamed Charing Cross Hospital in 1827, and plans were made to build a much larger hospital. The new hospital opened in 1834 in Agar Street with sixty beds. Although extended many times, the site was too cramped, with no possibility of further expansion.

The hospital joined the NHS in 1948, but it was decided that it should move out of central London. It closed in 1973, when the new Charing Cross Hospital opened on the site of the old Fulham Hospital in Hammersmith, several miles west of the city centre.

Fig. 26: Wounded servicemen being brought to the Casualty Department entrance during the First World War.

*The building remained vacant for some time, but in the early 1990s, it was completely refurbished and became the Charing Cross Police Station.*

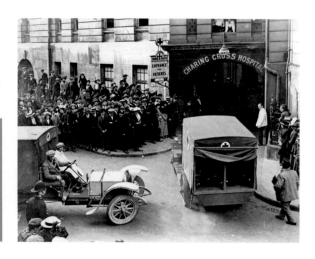

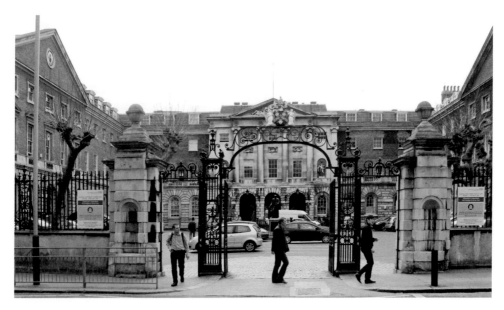

Fig. 27: The entrance in St Thomas Street. Sir Thomas Guy was reburied in the hospital chapel in 1780.

Guy's Hospital opened in 1726. Founded by the printer and publisher of unlicensed Bibles, Sir Thomas Guy, it was an institution for elderly and chronically sick 'incurables' discharged from St Thomas' Hospital, who had nowhere to go. The hospital, built on land rented from St Thomas' Hospital, had 100 beds (it was intended eventually to have 435). In 1739, an east wing was built and, in 1744, a twenty-bedded 'Mad House'. The west wing was completed in 1780, by which time the institution had developed into a general hospital. In 1799, a dental surgeon was appointed to the staff – the first in a London hospital. In 1829, a bequest of £200,000 by William Hunt enabled the hospital to be extended to the south with an extra 100 beds (Hunt's House was replaced in 1999 by New Hunt's House). A dental school was established in 1888. In 1935, Nuffield House, the private patients' wing, was built. During the Second World War, the buildings suffered severe bomb damage.

The hospital joined the NHS in 1948 with 692 beds. In 1963, an eleven-storey surgical block opened. In 1974, the thirty-four-storey Guy's Tower was added to house the medical departments and the dental school (the largest in Europe). A new Thomas Guy House was completed in 1995. The site now contains numerous buildings of many architectural styles. The venerable original buildings are used as administration offices.

*The hospital is now managed by the Guy's and St Thomas' NHS Foundation Trust. It has 400 beds. Its postal address has been changed to Great Maze Pond.*

# King's College Hospital
## Denmark Hill, SE5 9RS

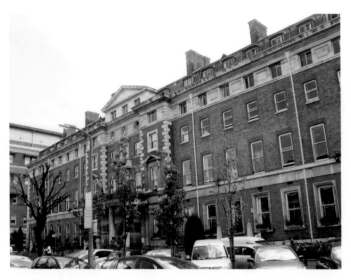

Fig. 28: The original building on Bessemer Road is now the Hambledon Wing.

In 1903, the Hon. William Frederick Danvers Smith (later Lord Hambledon) purchased 12 acres of land in Denmark Hill and presented it to King's College Hospital, then located off Kingsway, as a site for a new hospital. This opened in 1913 with 600 beds. The central administrative block was flanked by six ward pavilions arranged in parallel. The Outpatients Department could seat 500 people and had a permanent refreshment counter in the centre. There was a separate entrance in the Children's Department for patients with whooping cough. The hospital had an internal telephone system, the second in the United Kingdom, while the buildings incorporated many innovations, such as rounded walls and ceiling and floor junctions to prevent dust from gathering in corners. Power for lighting was supplied by diesel engines (until 1955). Within a year, however, the First World War had broken out and several wards were requisitioned for use as a military hospital – the Fourth London General Hospital (decommissioned in 1919). Only four wards and the Casualty Department remained for civilian patients. A Dental School and Hospital opened in 1923. During the Second World War, the operating theatres were relocated to the basement, and patients in the higher wards were also moved to the basement during bombing raids. The hospital became a casualty receiving centre. Amazingly, apart from incendiaries, it was hit only once by a small bomb.

It joined the NHS in 1948. More buildings were added during the 1990s, including a new Accident and Emergency Department. In 2003, the Golden Jubilee Wing opened and, in 2010, the Cicely Saunders Institute for palliative care.

*The hospital is still operational. It has 950 beds and employs some 6,000 staff.*

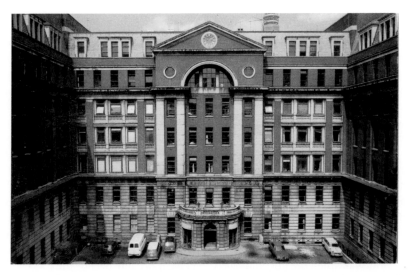

Fig. 29: The front entrance with its courtyard car park. The hospital was named after the county in which it stood (the county of London was not established until 1888).

The Middlesex Infirmary 'for the Sick and Lame of Soho' opened in 1745 with fifteen beds in two houses in Windmill Street. In 1747, it became the first hospital in England to provide 'lying-in' beds for pregnant women. As demand for beds increased, patients were also accommodated in neighbouring houses. The hospital had forty beds, but new premises were needed (the matron thought it 'undesirable that there should be two in a bed as sometimes was found necessary'). In 1757, it moved to a purpose-built building in Mortimer Street, then at the extreme edge of London, separated from Tottenham Court Road by marshland ('a good place for snipe-shooting'). By 1848, following further extension, it had 240 beds. However, by 1924, the main building was in danger of collapse and a Dangerous Structure notice was served. In 1926, the adjacent Cleveland Street Infirmary was taken over as an annexe (later becoming the Outpatients Department) and inpatients were moved there while the hospital was demolished in stages and entirely rebuilt on the same site. Completed in 1935, it had 712 beds. During the Second World War, the top three floors were emptied for safety reasons, and were indeed damaged by bombs. As a teaching hospital, its staff were in charge of one of the EMS sectors, with an advanced base hospital at Mount Vernon Hospital (*see p. 62*).

In 1948 it joined the NHS, closing in 2006 when all services moved to the new £422 million PFI-built University College Hospital in Euston Road.

*The site is currently (2014) being redeveloped for housing and shops. It is to be called Fitzroy Place. The outpatients annexe remains in limbo.*

# Royal Free Hospital
## 256 Grays Inn Road, Holborn, WC1X 8LD

The London General Institution for the Gratuitous Cure of Malignant Diseases opened in 1828 in a house in Hatton Garden, providing free treatment without the need of a subscriber's letter (as demanded by the voluntary hospitals). It had been established by Dr William Marsden, who had found a young girl dying on the steps of St Andrew's church, Holborn. She had been refused admission to three hospitals because she had no subscriber's letter, so he cared for her himself until she died two days later. Initially a dispensary, the institution soon had thirty beds. In 1833, it became the London Free Hospital, then simply the Free Hospital. When Queen Victoria became its patroness in 1837 in recognition of it being the only London hospital to admit cholera victims during the 1832 epidemic, it was renamed the Royal Free Hospital. In 1844, it moved to a former barracks in Grays Inn Road, where it had 152 beds. The patients lived in much the same rough conditions as the soldiers had done before them, but the buildings were gradually improved or replaced. It became a teaching hospital in 1877 with one of the largest outpatient Departments in London. A new block completed in 1915 was immediately requisitioned by the War Office during the First World War as a military hospital for officers with 150 beds. During the Second World War, when the hospital had 327 beds, it became part of the EMS.

The Royal Free Hospital joined the NHS in 1948. The war damage from a flying bomb in 1944 was gradually repaired, but it was felt there were too many teaching hospitals in central London. The old hospital closed in 1974 when the new one opened in Hampstead.

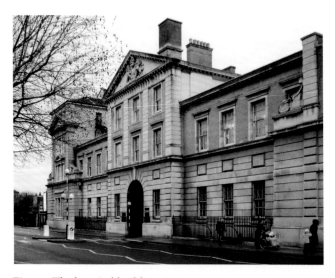

Fig. 30: The hospital buildings in 2009.

*The Eastman Dental Hospital took over the buildings in 1988. Originally the Royal Free's dental department, it became an independent postgraduate teaching hospital in 1948.*

# Royal London Hospital
## Whitechapel Road, Whitechapel, E1 1BB

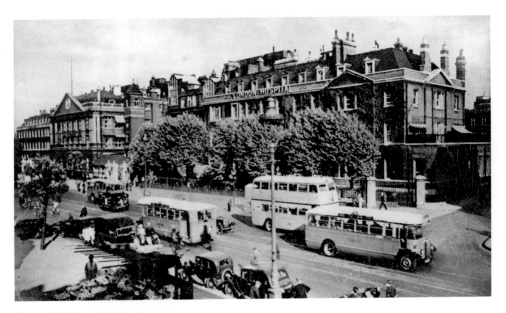

Fig. 31: The hospital in the 1950s.

The London Infirmary opened in 1740 in a house in Moorfields, leased by the surgeon John Harrison and six others to care for the sick inhabitants of the East End slums. It had thirty beds but, by 1744, had been extended twice. By 1748, it had become the London Hospital. In 1751, land along the desolate Whitechapel Road was purchased for a new hospital with 350 beds. Completed in 1759, it was extended in 1840. Two more wings were added in 1886, making it the largest voluntary hospital in the country with almost 1,000 beds. Because of the number of Jewish patients, it had a special kitchen for kosher food. During the Second World War, its staff established EMS sector hospitals outside London, but a large casualty department was kept open for air-raid victims. Some 137 bombs fell in its grounds; the east wing was demolished by a V1 rocket in 1944 and two patients were killed.

In 1948, it joined the NHS with 925 beds. In 1990, its 250th anniversary, it was renamed the Royal London Hospital. In the same year, the London Air Ambulance service was introduced, and a helipad was built on the roof of the West Wing. In 1995, the hospital merged with St Bartholomew's and the London Chest Hospital (*see p. 76*) to form the Royal Hospitals NHS Trust. In 2007, old ward blocks were demolished and work began on a £650 million PFI-redevelopment of the site. The new buildings opened in 2012.

*The hospital is now run by the Barts Health NHS Trust and has 746 beds. The original buildings along Whitechapel Road remain a building site (2014).*

# St Bartholomew's Hospital
## West Smithfield, EC1A 7BE

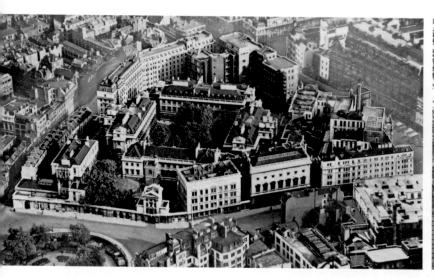

*Above left:* Fig. 33 A: The hospital is bounded by Little Britain on the left of the image, with West Smithfield in the foreground. The chapel-like structure is the Henry VIII gate.

*Above right:* Fig. 33 B: The main public entrance from West Smithfield is the Henry VIII Gate, dating from 1702.

Bart's is the oldest operational hospital in England, founded in London in 1123 for the sick poor of Smithfield, under the care of St Bartholomew's priory. It survived the Dissolution in the sixteenth century as Henry VIII held it in such high regard that he had it founded again by Royal Charter and granted it to the City of London. The hospital was rebuilt in the eighteenth century. The artist William Hogarth decorated the grand staircase in the North Wing, which opened in 1732. By 1872, it had 676 beds. During the First World War, the East Wing accommodated military patients. During the Second World War, the hospital received bomb damage, but most of the staff were working at EMS base hospitals established at Hill End and Cell Barnes Hospitals near St Albans.

In 1948, it joined the NHS as a teaching hospital with 785 beds. Threatened with closure in 1993 because of the low population in its catchment area, it was saved after a public campaign, although its Accident Department closed in 1995. In 1998, when it had 450 beds, it became a specialist cancer and cardiac hospital. A new cancer centre opened in 2010.

*No longer an acute general hospital, it has 388 beds and a Minor Injuries Unit.*

# St George's Hospital
## Hyde Park Corner, SW1X 7TA

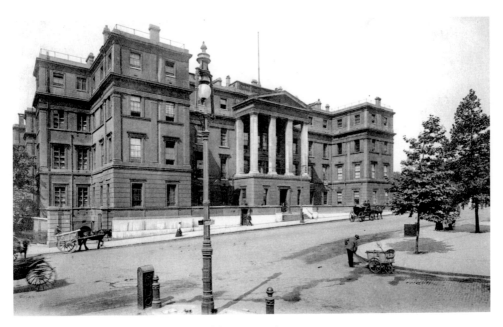

Fig. 34: The hospital at the beginning of the twentieth century.

St George's Hospital was established in 1733 following a schism with the Westminster Hospital (*see p. 39*). It opened at Lanesborough House at Hyde Park Corner in 1734, with thirty beds in two wards on the first floor and staff accommodation above. It was an instant success, and the hospital expanded rapidly. By 1747, it had 250 beds in fifteen wards. A separate room was made available for operations (previously carried out in the wards). By 1800, the building had fallen into disrepair, and between 1827 and 1834 it was demolished and the hospital rebuilt. By 1859, an attic floor had to be added to the new building as the demand for beds had exploded. In 1935, an electric lift was installed, replacing the manual one worked by a porter with a rope. During the Second World War, it provided 200 beds for air-raid casualties and sixty-five beds for the civilian sick, but most staff were evacuated to run EMS base hospitals outside London.

In 1948, the hospital joined the NHS. The need to rebuild it elsewhere had been recognised in 1946 and a location sought in south London. The adjoining sites of the Grove Hospital and Fountain Hospital (*see p. 105*) in Tooting – both with run-down buildings – were selected in 1950. Building work began at the Tooting site in 1973, and the first new ward block opened in 1979. The Hyde Park Corner building, with 269 beds, closed in 1980.

*The building is now a luxury hotel – again the Lanesborough. Its restaurant was once the Outpatients Department. The hotel closed in December 2013 for complete refurbishment.*

35

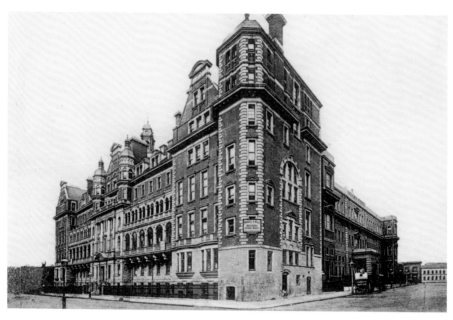

Fig. 35: The Clarence Wing.

St Mary's Hospital opened in 1851 for the gratuitous relief of the sick poor (except those with infectious diseases). Only fifty of the 150 beds were initially available. In 1854, a medical school was built behind the hospital. Further wings were added later to give 281 beds. More land was acquired in 1888, and work began on the building of the Clarence Wing in 1892. It was completed in 1904; laboratories were installed in 1907 (where Alexander Fleming, professor of bacteriology, discovered penicillin in 1928), and research wards in 1909. More land was acquired for expansion and, in 1933, a new building for the Medical School and the Pathological Institute opened. By 1935, the hospital had 384 beds. A private patient's wing opened in 1937, named after its donor, Frank Lindo.

The hospital joined the NHS in 1948 with 450 beds. The Winston Churchill Wing was added in 1959. A new Outpatients Department opened in 1966. In 1969, the Mint Stables in South Wharf Street, built for the Great Western Railway, were bought for hospital use. The Queen Elizabeth The Queen Mother Wing was added in 1987. In 1997, plans were proposed for a new PFI scheme – the Paddington Health Campus – to be built adjacent to the hospital around the Paddington canal basin (the Royal Brompton and Harefield Hospitals would also relocate to the site). However, the projected costs soared from £360 million to £1.1 billion and, after prolonged internal and external wrangling (and after £15 million had been paid in fees to architects, consultants, lawyers, etc.), the idea was abandoned in 2005.

*It remains an acute hospital with a major trauma centre.*

# St Thomas' Hospital,
## Westminster Bridge Road, Lambeth, SE1 7EH

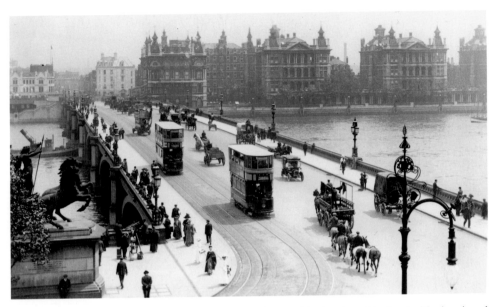

Fig. 36: The hospital was rebuilt in the 1860s in the 'pavilion' style, with the six blocks placed 125 feet apart.

Originally a monastic hospital located in Southwark, founded in the twelfth century and dedicated to St Thomas Becket, it had been dissolved by Henry VIII in 1541. Edward VI refounded it in 1555 as a secular institution dedicated to the apostle St Thomas. The hospital moved to Lambeth in 1871, having been built on land largely reclaimed from the river during the construction of the Albert Embankment. One of the first to be built on the 'pavilion plan' championed by Florence Nightingale, it had 588 beds. During the First World War it had 484 beds for civilians and 200 for military patients. In 1915, wooden huts were built between the ward blocks to accommodate 302 beds; these became the Fifth London General Hospital (which eventually had 530 beds; it closed on 31 March 1919). By 1935, the hospital had nine blocks (including a small Outpatients Department, added in 1931). During the Second World War, its EMS base hospital was established at Brookwood Mental Hospital, but the Lambeth buildings suffered such severe damage in the Blitz (the three northern ward blocks were completely destroyed) that most of the remaining staff had to be evacuated to Godalming, keeping only 184 beds open for civilian casualties.

The hospital joined the NHS in 1948, but limited reconstruction only began in the 1950s. New buildings were added in the 1960s. A thirteen-storey North Wing was built in 1975, but public dismay at its scale and appearance ensured a second was never erected.

*The three surviving Victorian ward blocks, now Grade II listed, were refurbished during the 1980s. In 1993, it merged with Guy's Hospital. In 2005, it became the home of the Evelina London Children's Hospital.*

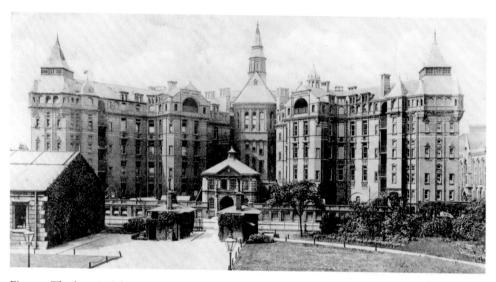

Fig. 37: The hospital frontage as seen from the grounds of University College London on the other side of the road. Known as the 'Cruciform Building', its unusual design was an attempt to solve the problems of ventilation, drainage and lighting.

The North London Hospital was founded by University College London in 1834 with 130 beds. A wing was added in 1841, and another in 1846. However, by 1877, it was too small and a new hospital with 300 beds was built in 1906 on the same site. In 1907, it separated from University College London, which was suffering financial problems. It was renamed University College Hospital in 1937. At the outbreak of the Second World War in 1939 it established EMS base hospitals in Watford and Stanmore.

It joined the NHS in 1948. Cecil Fleming House opened in Grafton Way in 1969 to house a new Outpatients Department and Accident Clinic. Services continued in this building (which had sixty-three beds) when the Cruciform Building closed in 1995, until the new £422 million PFI hospital on Euston Road opened in 2006.

Fig. 38: The new hospital was built adjacent to the old one, which can just be seen on the left.

*The Cruciform Building was purchased by University College London. It is now the Wolfson Institute for Biomedical Research and the preclinical teaching facility for the Medical School.*

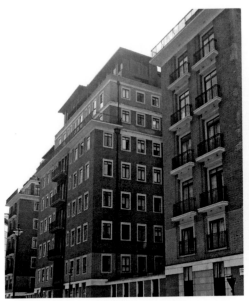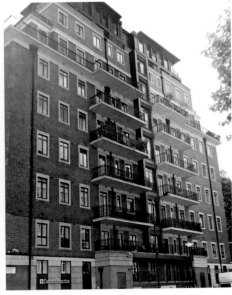

Fig. 39: The eastern elevation in Dean Ryle Street (*left*) and the northern elevation in Horseferry Road (*right*).

The Infirmary for the Sick and Needy opened in 1720 with ten beds in Pimlico, moving to a larger property with thirty-one beds in 1724. Westminster was one of the most desolate places in London, and the most common admissions were for malaria or typhoid. Patients benefitted mainly by rest and regular meals, in contrast to their filthy and appalling living conditions at home. In 1733, a row broke out over the proposed site of a new hospital and the entire medical staff resigned, leaving to found St George's Hospital (*see p. 35*). In 1735, it moved to Buckingham Gate as the Westminster Infirmary for the Sick and Infirm. By 1760, it had ninety-eight beds and was known as the Westminster Hospital. A new hospital was built at Broad Sanctuary, which opened in 1834 – with plumbing problems. The stench from the ward WCs permeated the building, while the two baths in the basement (for 100 patients) drained into a cesspool. Although reconstructed in 1895, the building deteriorated and closed for major refurbishment in 1924. This gave only temporary relief, so a new hospital was built at St John's Gardens, opening in 1939. During the Second World War, despite being struck by bombs twice in 1940 and by a land mine exploding nearby in 1941, it continued to function. It joined the NHS in 1948 as a designated teaching hospital. A new wing was added in 1966. It closed in 1992 with 403 beds, relocating to the new Chelsea and Westminster Hospital in Fulham Road.

*The hospital has been converted into Westminster Green, a luxury apartment block.*

# Chapter 4

# Postgraduate and Specialist Hospitals

Once qualified, doctors could choose to specialise in a particular branch of medicine as postgraduate students. Many specialist hospitals became postgraduate teaching hospitals on joining the NHS, as did a few general hospitals.

Specialist hospitals had been established mainly in London, as good railway links enabled patients to attend from all over the UK. It seems a hospital existed for every anatomical part of the body: skin, eyes, ears, throats, bones, kidneys, digestive system, heart, lungs, nerves and even the feet. Many became world famous for developing new treatments. Hospitals for women began to appear in the 1840s, some as general hospitals only admitting women and young children (a few were staffed solely by women), others specialising in gynaecological disease. Eye hospitals developed mainly because soldiers, who had acquired eye diseases while on service in Egypt and India, began to spread them to civilians. Children's hospitals developed somewhat later; the Hospital for Sick Children in Great Ormond Street opened in 1872, the first in England.

The first to specialise in cancer care was the Royal Cancer Hospital, which opened in 1852, although little could be offered in the way of treatment until the discovery of X-radiation and radium at the end of the century. Hospitals for 'incurables' also appeared in the mid-nineteenth century, while hospices for the dying offered the comfort of a domestic environment. Orthopaedic hospitals emerged in the early twentieth century, treating skeletal deformities and tuberculosis of the spine, hip and other joints, which involved immobilisation and many months, even years, of hospitalization.

Most have now closed, their work taken over by specialist departments within larger teaching hospitals.

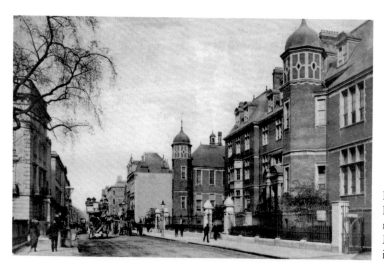

Fig. 41: The Cancer Hospital was later renamed the Royal Marsden Hospital. It is still operational.

# Elizabeth Garrett Anderson Hospital
## 144 Euston Road, NW1 2AP

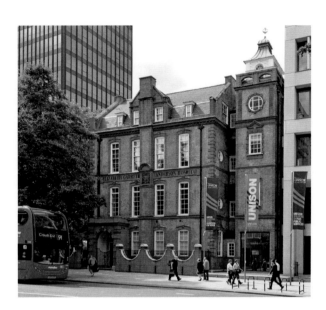

Fig. 42: The Grade I listed Queen-Anne-style building has been restored. It contains the Elizabeth Garrett Anderson Gallery.

In 1865, Elizabeth Garrett became the first woman doctor in the UK, despite great opposition from the medical establishment. In 1866, she opened St Mary's Dispensary in Seymour Place to provide treatment for women. She obtained a medical degree from the University of Paris in 1870, and the following year married James Anderson, a successful businessman. In 1892, a small ward opened at the Dispensary, which was renamed the New Hospital for Women (and staffed entirely by women). In 1874, it moved to Marylebone Road and then, in 1890, to a new purpose-built hospital in Euston Road. Following her death, it was renamed Elizabeth Garrett Anderson Hospital in 1918. The Queen Mary Wing opened in 1929.

In 1948, it joined the NHS as a teaching hospital. It first became threatened with closure when the General Nursing Council stopped training nurses there. In 1976, the lifts and fire escapes were declared unsafe and the Secretary of State decided it should close. A major national campaign prevented this and it reopened in 1984 as a gynaecological unit. In 1988, the Hospital for Women in Soho closed and its services moved to the Euston Road site, bringing male gynaecologists to the staff. It was renamed the rather overlong 'United Elizabeth Garrett Anderson Hospital and Hospital for Women, Soho'. The beds closed in 1992, after which only day surgery was performed. In 2000, it merged with the Obstetric Hospital at University College Hospital, moving to Huntley Street to become the Elizabeth Garrett Anderson and Obstetric Hospital (closing in 2008). A tower of the new University College Hospital is named the Elizabeth Garrett Anderson Wing.

*All but the original building has been demolished and the site now contains the headquarters of Unison, the Health Service workers' union.*

# Hammersmith Hospital
## Du Cane Road, Wormwood Scrubs, W12 0HS

The Hammersmith workhouse opened in 1905 on a site adjacent to Wormwood Scrubs Prison. An infirmary with 330 beds was built along Du Cane Road, but caused an immediate outcry on its opening. The lavish building had cost £261,000 (a huge sum in those days), and the press dubbed it the 'Paupers' Paradise'. During the First World War, the workhouse and infirmary became the Military Orthopaedic Hospital, Shepherd's Bush (later the Special Surgical Hospital). In 1930, the institution passed to the LCC, who renamed it the Hammersmith Hospital. It was chosen to host the new Postgraduate Medical School of the University of London, which opened in 1935. During the Second World War, the Radiotherapy Unit belonging to the Medical Research Council moved to the site (where it still remains) and a shaft sunk to bury the radium to protect it. The buildings suffered bomb blast damage.

The hospital joined the NHS in 1948 as a teaching hospital. By the 1950s, it had 694 beds. In 1966, nurses with bedrooms facing the prison were being kept awake by the bright floodlighting along the prison perimeter, installed after the spy George Blake escaped. In 1994, the hospital was the first in Europe to use filmless X-rays. In 1997, the Royal Postgraduate Medical School merged with Imperial College. In 2000, Queen Charlotte's and Chelsea Hospital moved from Goldhawk Road to purpose-built premises on the Du Cane Road site.

*The hospital is still operational and now part of the Imperial College Healthcare NHS Trust.*

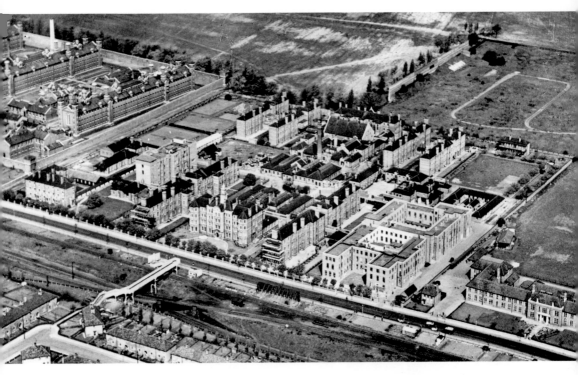

Fig. 43: An aerial view of the campus.

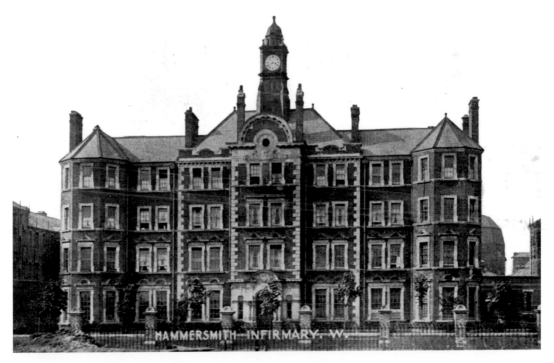

Fig. 44: The rather splendid central administration building of the infirmary.

Fig. 45: No. 40 Fitzroy Square (*left*) and No. 33 Fitzroy Square (*right*) are at opposite ends of the south terrace. The buildings were damaged during the Second World War, but the stone façade of the terrace was later restored, with new office accommodation built behind it.

The Pedic Clinic opened in November 1913 in Silver Street, Bloomsbury. The first clinic of its kind in the country, it can be regarded as the birthplace of British chiropody. The School of Podiatric Medicine finally opened in 1919, delayed by the outbreak of the First World War, the first to undertake systematic teaching of chiropody with the active support of the medical profession. In 1920, the clinic moved to Charlotte Street and, in 1924, it was renamed the London Foot Hospital. In 1929, the freehold of No. 33 Fitzroy Square was acquired, and the hospital and school moved there. Clinical and educational work expanded but, in 1939, war intervened again. In 1940, the southern side of Fitzroy Square was badly damaged by a bomb. Emergency clinics were improvised at the hospital and the next day patients were treated as usual. Teaching also continued. In the post-war period, there was a large influx of students, including many ex-service personnel with government grants. Lectures were held at the London Skin Hospital at the other end of the terrace – No. 40 Fitzroy Square.

In 1948, the hospital joined the NHS. In 1959, it purchased No. 40 Fitzroy Square. In 1994, its closure was mooted as the building was deemed unsuitable for patients on Health and Safety grounds; no lifts could be installed, so non-ambulatory patients had to be carried upstairs. It closed in 2003, after a long-running dispute.

*The Grade I listed buildings were sold. No. 33 has been converted into a private residence, while No. 40 has been refurbished and is now a private cosmetic clinic.*

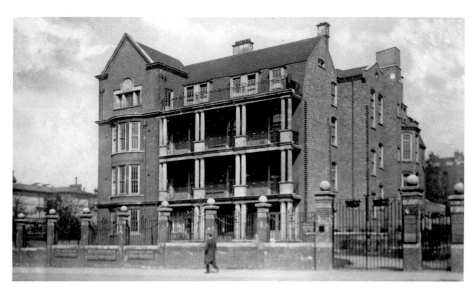

Fig. 46: The hospital was built in 1902.

Founded by the German physician Julius Althaus, the London Infirmary for Epilepsy and Paralysis opened in 1867 in Charles Street (now Blandford Place) for outpatients only. In the following year, a few inpatients were admitted. When the lease expired in 1872, it moved to Winterton House on the north of Regent's Park, where it had twenty beds. In 1873, its name was considered too similar to the National Hospital for the Paralysed and Epileptic in Queen Square (*see p. 46*), and was changed to the Hospital for Diseases of the Nervous System until 1876, when it became the Hospital for Epilepsy and Paralysis. In 1890, an anonymous gift of £1,200 enabled the lease to be renewed, but a new building was urgently needed. In 1900, a site in Maida Vale was obtained. The first part of the hospital opened in 1902 (lack of funds prevented completion) with thirty-eight beds, an Outpatients Department and a dispensary, but no laboratories or radiology department. It was eventually completed in 1913 (an anonymous donor had walked in and handed the secretary a £1,000 note), when it had seventy beds. In 1937, it became the Maida Vale Hospital for Nervous Diseases. During the Second World War it was hit by a high explosive bomb, but the small number of patients had been moved to the basement, and there were no casualties. The Outpatients Department kept functioning.

In 1947, it merged with the National Hospital in Queen Square and, on joining the NHS in 1948, they became a single postgraduate teaching hospital – the National Hospitals for Nervous Diseases. By 1956, the bomb damage had been repaired and the hospital had ninety beds. In 1974, it had eighty-four beds, but the building had become run down and neglected. It closed in 1983 and the site sold.

*The building was demolished and its site redeveloped as a luxury apartment block.*

Johanna Chandler and her siblings, Louisa and Edward, formed the idea of a hospital for the paralysed after the death of their beloved grandmother, who had looked after them since they had been orphaned. The old lady had been paralysed for a number of years but no institution catered for such patients. To raise money for the venture, the women made and sold small ornaments of shells and beads. The appeal caught the attention of the Lord Mayor of London, himself partially paralysed, who formed a committee for the establishment of the special hospital. The National Hospital for the Paralysed and Epileptic opened in 1860 at No. 24 Queen Square with eight beds for women; a male ward was added a few months later. In 1866, the house next door was purchased. In 1870, a convalescent home opened in East Finchley (*see p. 63*). During the 1880s, the houses were demolished and the hospital rebuilt. A surgical wing was added in 1891. In 1909, it was extended again. During the First World War, seventy beds were reserved for servicemen with neurological injuries. In 1926, it was renamed the National Hospital for the Relief and Cure of Diseases of the Nervous System Including Paralysis and Epilepsy. A large extension was built in 1938, but was severely damaged during the Second World War. In 1947, it merged with the Maida Vale Hospital (*see p. 45*), both joining the NHS in 1948 as the National Hospitals for Nervous Diseases.

*Today it is known as the National Hospital for Neurology and Neurosurgery, the largest of its kind in the UK, with 244 beds.*

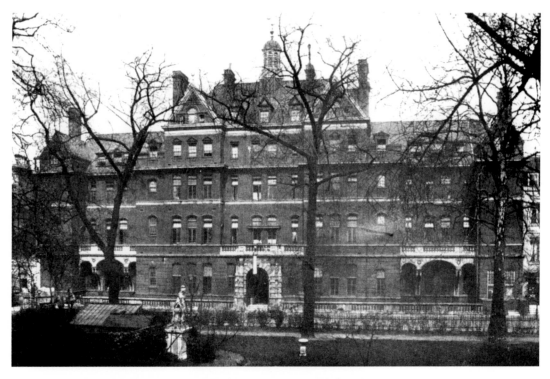

Fig. 47: The original purpose-built building is now Grade II listed.

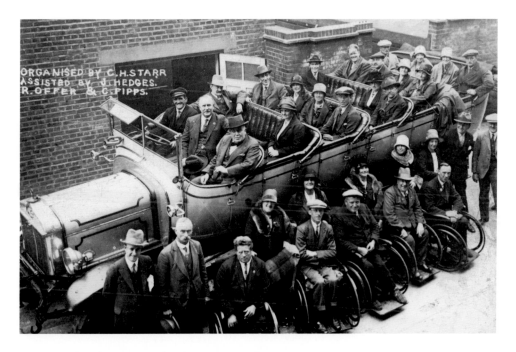

Fig. 48: A charabanc outing for the patients in the 1920s.

 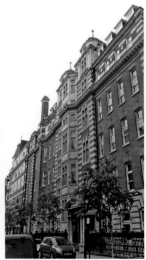 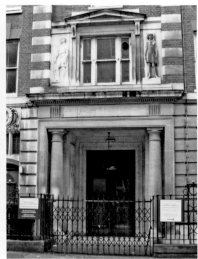

*Above left and middle:* Fig. 49 A&B: The western façade of the Hospital building in Great Portland Street is now part of the privately run Portland Hospital for Women and Children. The eastern façade in Bolsover Street (*above centre*) is Central Park Lodge, an apartment block.

*Above right:* Fig. 49 B: The entrance to the Out-Patients Department, now demolished.

Originally an amalgamation of the National Orthopaedic and the Royal Orthopaedic Hospitals, the Royal National Orthopaedic Hospital opened in 1905 in a new building with 213 beds on the site of the National Orthopaedic Hospital (the City Orthopaedic joined the merger in 1907). In 1909, an Outpatients Department was built on the opposite side of the road in Bolsover Street, connected to it by a subway. During the First World War, the first-floor ward was retained for civilian cases, and the remainder reserved for military patients. At the end of the war, the Ministry of Pensions requested that discharged disabled servicemen were treated instead of serving ones. In 1922, as 75 per cent of its patients were children, afflicted variously with tuberculosis and deformities of the spine or limbs, a country branch was established at Brockley Hill, Stanmore (*see p. 18*) for their long-term care. In 1927, the Outpatients building was extended. During the Second World War, the hospital escaped bomb damage, although houses nearby were destroyed. In 1946, the Institute of Orthopaedics was established, located on the first floor of the building (the larger research departments moved to the Stanmore site in 1948).

In 1948, the hospital joined the NHS as a postgraduate teaching hospital with ninety beds. Its lease expired in 1984. Inpatient services moved either to the Stanmore site or to the Middlesex Hospital (*see p. 31*), while outpatient services remained in Bolsover Street.

*In 2008, the outpatients building in Bolsover Street was sold for redevelopment and a new centre built at No. 45 Bolsover Street, opening in 2009.*

# The 'Three Ps'

## St Peter's Hospital
### 27 Henrietta Street, WC2E 8NA

The Hospital for Stone and Diseases of the Urinary Organs opened in 1860 in Great Marylebone Street with few, if any, beds. It was the first to specialise in the removal of bladder stones. Lithotomy (removal by open operation, which had a high mortality rate) was replaced with newer methods of crushing or dissolving the stones (lithotrity). As patient numbers increased, a large house in Berners Street was leased in 1863. It became St Peter's Hospital for Stone with fifteen beds. The average stay was 100 days, and the mortality rate following lithotrity was 15.2 per cent. On 11 February 1873, a stranger presented a sealed packet to the hospital secretary, which contained ten £1,000 notes (such notes were withdrawn in 1943). No stipulations were made as to how to use the money. The committee looked for more suitable premises, found a site in Covent Garden and a purpose-built hospital opened in 1882. It gradually built up a reputation for the successful removal of bladder stones using litholapaxy (crushing the stone and evacuating the debris from the bladder). The mortality rate for this procedure (with antisepsis) was 2.2 per cent during 1915–24, with a short stay in hospital. In 1918, an elderly man, admitted for

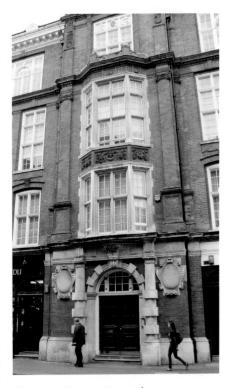

Fig. 50: St Peter's Hospital.

a prostatectomy, asked to see the hospital secretary. He explained that he had been the bearer of the anonymous gift forty-five years ago on behalf of the donor. The donor had since died, but his name was confided to the secretary. At a secret meeting, the committee made no note of it in the minute book and thus the 'Friend of the Hospital' remains forever anonymous. The hospital closed during the Second World War.

In 1948, under the control of the NHS, St Peter's and St Paul's Hospitals were amalgamated as a postgraduate teaching hospital group. St Philip's Hospital joined them in 1952, and they were known locally as 'The Three Ps'. The Shaftesbury Hospital (*see p. 8*) joined in 1967. The hospital closed in 1992 with forty-one beds, as did the other two 'Ps'. Services moved to the Middlesex Hospital (*see p. 31*).

*The former hospital has been converted into seven large apartments.*

## St Paul's Hospital
### 24 Endell Street, WC2H 8AE

Fig. 51: 'The Hospital'.

St Paul's Hospital opened in 1898 as a clinic in Red Lion Square, providing treatment primarily for venereal disease (VD). When finances allowed, six beds were available. During the First World War, a government-funded clinic opened to provide free confidential VD treatment (in its first year it dealt with 606 inpatients and 20,000 outpatients). Needing new premises, in 1919 the former British Lying-In Hospital building in Endell Street was purchased but, because of financial difficulties, was not occupied until 1923. In 1927, it was renamed St Paul's Hospital for Diseases (including Cancer) of the Genito-Urinary Organs and Skin. It closed at the beginning of the Second World War but, due to popular demand, reopened and continued to work within wartime limitations. It joined the NHS in 1948, amalgamating with St Peter's Hospital. It closed in 1992 with forty-nine beds.

*It is now 'The Hospital', a media club and restaurant.*

## St Philip's Hospital
### Sheffield Street, WC2A 2EX

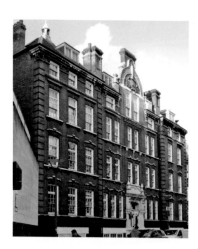

Fig. 52: St Philip's Hospital was built in 1903 as a workhouse.

In 1919, the Ministry of Health was concerned about the provision for young girls and women with VD, who had been infected as a result of an 'occasional lapse into immorality' and had fallen into the hands of the Women Police patrols. The Metropolitan Asylum Board purchased the Strand Union workhouse and, in 1920, adapted it for use as a hospital for these women. In 1930, it came under the control of the LCC and was renamed Sheffield Street Hospital. It had fifty-two beds. In 1948, it joined the NHS with fifty-seven beds, dealing with chronic urological cases. Renamed St Philip's Hospital in 1952, it became the third member of the 'three Ps' group – hospitals specialising in diseases of the kidneys and urinary system. By 1969, it had twenty-six beds. It closed in 1992 and services moved to the Middlesex Hospital (*see p. 31*).

*The building is now occupied by the London School of Economics.*

# West London Hospital
## 202 Hammersmith Road, W6 7DG

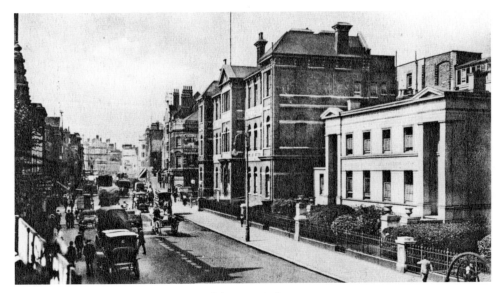

Fig. 53: The hospital at the beginning of the twentieth century.

The Fulham and Hammersmith General Dispensary opened in 1856 in Queen Street. In 1860, increasing demand led to the leasing of Elm Tree House in Hammersmith Road, where it became the West of London Hospital and Dispensary (its inpatients were mainly victims of industrial accidents). In 1863, it was renamed the West London Hospital. Elm Tree House was purchased in 1868 and enlarged. New wings were added in 1871, 1883, 1898 and 1925. In 1937, the Silver Jubilee Extension was officially opened by Queen Mary. The hospital also undertook teaching activities. The small postgraduate centre, established in 1893, gradually became an undergraduate medical school, incorporated in 1937.

It joined the NHS in 1948 as a Special Teaching Hospital with 239 beds. The medical school was deemed too small; the last entry of undergraduates was in October 1948, but postgraduate teaching continued. The A&E Department closed in the 1970s, the service moving to the new Charing Cross Hospital in Fulham Palace Road. Renowned from the early 1970s for its female-centred maternity department, the hospital finally closed in 1993; all services moved to the new Chelsea and Westminster Hospital in Fulham Road.

Fig. 54: The Saunders Building in 2009.

*The building was sold and refurbished as self-contained air-conditioned offices (renamed the Saunders Building). The façade is listed and has been preserved.*

# Chapter 5

# North-West Metropolitan Region

As well as north and nort-hwest London, this region included hospitals in parts of Middlesex, Hertfordshire, Berkshire and Bedfordshire.

In 1948, it contained around 152 hospitals, of which the larger originally had been workhouse infirmaries. Despite the increasing availability of powerful drugs, tuberculosis remained a problem and the sanatoria at Clare Hall, Harefield and Mount Vernon continued in operation until the mid-1950s, when they diversified into other specialties.

Following a major reorganisation of the NHS in 1974, many of the smaller general and cottage hospitals began to close, with their services moving to the bigger hospitals, which became even larger. Government policy also dictated that maternity units should be placed in district general hospitals, so that all emergency facilities would be available if necessary. Thus, maternity hospitals also closed.

By the end of the twentieth century, less than a third of the hospitals in the original North-West Metropolitan Region remained.

Fig. 55: The dispensary at the King Edward VII Hospital in Windsor at the beginning of the twentieth century.

# Acton Hospital
## Gunnersbury Lane, Acton, W3 8EG

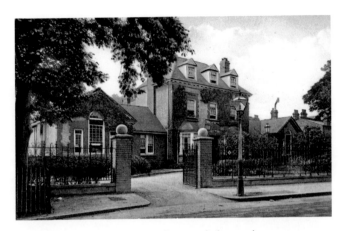

Fig. 56: The hospital was much extended over the years.

In 1897, the philanthropist John Passmore Edwards donated £2,500 towards the building of a hospital in Acton to mark Queen Victoria's Diamond Jubilee. Lord Rothschild and Mr Leopold de Rothschild of Gunnersbury Park donated the land, and the Passmore Edwards Cottage Hospital opened in May 1898 with twelve beds. By 1904, it had twenty-four beds and an Outpatients Department. In 1909, an operating theatre and a children's ward were added. In 1915, during the First World War, it was renamed Acton Hospital. One ward was set aside for military patients, along with the Committee Room, which had been converted into a ward. A War Memorial Wing with two wards opened in July 1923, when the hospital was renamed the Acton War Memorial Hospital. Considered to be one of the finest suburban general hospitals, it was extended in 1928 and 1936. At the outbreak of the Second World War, it became part of the EMS; its complement of seventy-two beds was supplemented by forty-two EMS beds.

It joined the NHS in 1948 as a general hospital with eighty-four beds. In 1975, it became a community hospital and then, in 1979, a geriatric hospital. It finally closed in 2001.

Fig. 57: Only the original building survives. It has been restored and serves as a multi-faith centre.

*The site continues to serve the local community. The other buildings have been replaced by the Acton Care Centre, which opened in 2003 for care of the elderly.*

Fig. 58: The hospital at the turn of the century.

The Bushey Heath Cottage Hospital opened in 1898 with twenty beds in two wards. Its first Honorary Secretary was W. S. Gilbert of Savoy Operas fame, who lived in nearby Grims Dyke. A wide range of medical and surgical care was provided, including dental surgery, but as in other cottage hospitals, those with infectious diseases, mental disorders or advanced lung conditions were excluded. In 1935, the word 'cottage' was dropped from its title. In 1936, an extension was built, which contained a new entrance hall, a ward with fourteen beds, private wards and an X-ray Department. A nurses' home opened in 1937.

In 1948, the hospital joined the NHS with thirty-eight beds and immediately was involved in a battle with the Peace Memorial Hospital in Watford to keep its 'general' status. The battle was won in 1950, but the pressure to transfer services either to Watford or Edgware General Hospital did not go away. During the 1970s and 1980s, numerous changes of policy by the Local Health Authority resulted in closure of the operating theatre and Outpatients Department, despite local protest. The hospital, with twenty-six beds, became a care centre for geriatric patients. In 1987, a Day Unit with fifteen places opened. The Health Authority proposed to develop four community care centres, one of which was to be at the hospital site. In 1990, the hospital closed and the buildings were demolished.

*The site has been redeveloped and now contains the Schopwick Surgery and Windmill House Rehabilitation Unit.*

# Central Middlesex Hospital
## Acton Lane, Park Royal, NW10 7NS

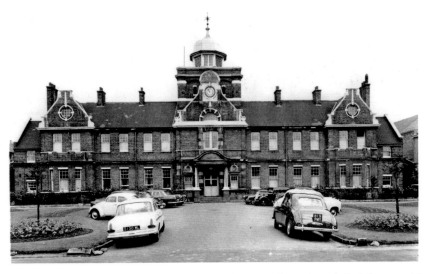

Fig. 59: The central administration building has now been demolished, but an old cupola and a flagpole were preserved. Old foundation stones are now displayed in the new hospital grounds.

In 1897, the Willesden Board of Guardians acquired a 64-acre site in Acton Lane for a workhouse and infirmary, which opened in 1903. The buildings accommodated 400 people, including 150 sick. By 1907, only sick paupers were admitted to both buildings, now known as the Willesden Workhouse Infirmary, which was extended in 1908, 1911 and 1914. By 1921, it was known as the Park Royal Hospital. In 1930, Middlesex County Council took over control and renamed it the Central Middlesex County Hospital. It had 689 beds. Extended again, by 1939 it had 890 beds. During the Second World War it was badly damaged by bombs.

The infirmary joined the NHS in 1948 with 842 beds. In 1966, a maternity unit with twenty-eight beds was built but, overall, the bed number had been reduced to 736, mainly for acute admissions. In 1997, construction work began on a new hospital building – the Ambulatory Care and Diagnostic Centre (ACaD) (what we used to call an Outpatients Department), which opened in 1999. Clinical services transferred from the old buildings to the new, and the second phase of rebuilding began in 2003. Most of the old buildings were demolished, but the Old Refectory survived. The inpatients wing – the Brent Emergency Care and Diagnostic Centre (BECaD) – opened in 2006, with 214 beds. However, the Brent Birth Centre, which was built in 2004, closed in 2008 and was relocated to Northwick Park Hospital.

*The new £29 million PFI-funded buildings are behind the original site, which now forms the forecourt. Some of the demolition material was used as foundations for the new car park and roads. The remainder of the site has been developed for key worker housing and businesses.*

# Colindale Hospital
## Colindale Avenue, NW9 5HG

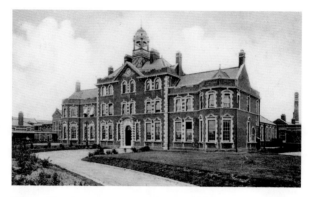

Fig. 60: The three-storey central part contained administrative offices and a chapel. The two two-storey ward pavilions either side could accommodate 240 patients.

By 1890, the Cleveland Street Infirmary of the Central London Sick Asylum District had become overcrowded, but the cost of land in central London was prohibitive and it was decided to build a new infirmary as far out of town as practicable. A site at Colindale was selected as easily accessible from the Edgware Road. The new infirmary opened in March 1900 with 274 beds, including separate wards for isolation cases and children. The operating theatre had a plate glass front wall and roof. In 1913, the Central London Sick Asylum District was dissolved and the infirmary sold to the newly formed City of Westminster Union, who renamed it the Hendon Infirmary. In December 1919, the Metropolitan Asylums Board took it over and it reopened in January 1920 as a tuberculosis hospice with fifty beds for male patients with advanced disease. In 1930, it came under the control of the LCC. A new wing with twenty beds was added in 1934.

In 1948, the hospital joined the NHS as the Colindale Hospital, continuing to specialise in tuberculosis cases. With the advent of antibiotic treatment for TB, it became a general hospital. Extended over the years, it had 350 beds, eventually closing in 1996.

Fig. 61: Later extensions to the hospital.

*Most of the hospital buildings became derelict and have been demolished, but the Grade II listed original block survives. The site is being redeveloped for new housing.*

56

# Finchley Memorial Hospital
## Granville Road, North Finchley, N12 0JE

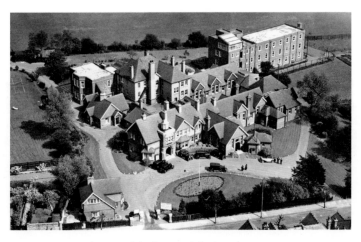

Fig. 62: An aerial view of the hospital during the 1930s.

Finchley Cottage Hospital opened in 1908 with twenty beds and a small operating theatre. Its president, Ebenezer Homan, had bought the site and also paid for the entrance lodge and gates. At the outbreak of the First World War, it was asked by the War Refugee Committee to treat sick Belgian refugees. This it did, while carrying on its own work. In 1916, an X-ray Department opened. An extension was built in 1922 as a war memorial to local men killed in the war. It was renamed Finchley Memorial Hospital and had forty-seven beds. In 1927, a Casualty Department opened with its own entrance, operating theatre, X-ray facilities and two small wards. In 1933, a private wing was built. During the Second World War, the hospital joined the EMS with seventy beds (increased by 1944 to eighty-four).

It joined the NHS in 1948. New X-ray and Physiotherapy Departments opened in 1958 and, in 1963, larger Casualty and Outpatients Departments. The ENT Department closed in 1974, deemed too small by the Department of Health. The operating theatres closed when new ones opened in Barnet General Hospital. The chapel, built in 1962, closed in 1980; patients were usually too ill to attend, so services were held on the wards. In the mid-1980s, acute medical work moved to Barnet, and it then became a hospital for the elderly with ninety beds. A Geriatric Day Hospital opened in 1987. Outpatient services continued and, in 2004, a walk-in centre opened for minor ailments. In 2007, the hospital was deemed 'not fit for purpose'. The adjacent disused playing fields were purchased in 2008 for a new £28 million community hospital, which opened in 2012. It continues the work of the old hospital, and includes a twelve-bed infusion suite for chemotherapy.

*The old buildings have been demolished and their site is now parkland with a memorial garden.*

# Grovelands
## The Bourne, Southgate, N14 6RA

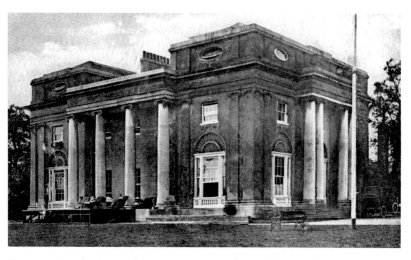

Fig. 63: Grovelands stood in extensive grounds, including a pleasure lake, some 7 acres in extent, visible from most windows of the house.

During the First World War, in 1916, Grovelands House, which had stood empty for eleven years, became the Southgate Auxiliary Military Hospital. In 1921, the Great Northern Central Hospital (later renamed the Royal Northern Hospital, *see p. 65*) acquired the site when the loan of its convalescent home in East Finchley expired. The Great Northern Home of Recovery opened in July 1921 with sixty beds. Female patients were accommodated in the drawing rooms and male patients in a newly built annexe, with a small children's ward on the floor above. Many of the rooms retained their original decoration from the late eighteenth century, executed by Italian artists brought over for the purpose. The nursing staff were accommodated on the top floor of the house (one bedroom opened out onto the roof, where the nurses could sleep on warm nights). The domestic staff were housed in the stables, converted into cubicles for the purpose. During the Second World War, the building was damaged by a bomb in 1941.

The home joined the NHS in 1948, along with its parent hospital. In 1973, it became a pre-convalescent unit containing fifty-six beds, providing nursing care for patients following surgery, thus freeing up acute beds at the main hospital. In 1974, after a major reorganisation of the NHS, the Royal Northern Hospital came under the control of the Islington District Health Authority while Grovelands was under the Enfield District Health Authority. It closed in 1977.

*The house remained unoccupied until it was sold in 1985. After extensive renovation the Grade I listed neo-classical villa reopened in 1986 as the Grovelands Priory, a private psychiatric hospital.*

# Hampstead General Hospital
## Haverstock Hill, Hampstead, NW3

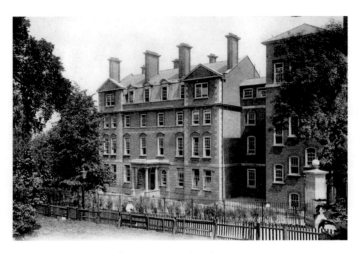

Fig. 64: A postcard of the hospital dated 1907.

The Hampstead Home Hospital and Nursing Institute was founded in 1882 in Parliament Hill Road by Dr W. Heath Strange to provide treatment for paying patients. In 1894, when it had twenty-nine beds, it was renamed Hampstead Hospital. In 1902, it was renamed the Hampstead General Hospital. By this time, the premises were too cramped. A site was found in Haverstock Hill for a purpose-built hospital, which opened in 1905 with fifty beds. In 1907, when it had sixty beds (only thirty-five were in use), it merged with the North West London Hospital in Kentish Town Road. Inpatients were treated at the new hospital, while outpatients continued to be seen in Kentish Town. In 1912, a new Outpatients Department was built in Bayham Street, Camden Town. The hospital was extended in 1929, when a Casualty Department was added. In 1939, an X-ray Department opened.

In 1948, it joined the NHS with 138 beds as part of the Royal Free Hospital Group. It was demolished in the 1970s to make way for the building of the new Royal Free Hospital.

> *Its site is now used as a car park and a small garden dedicated to Dr W. Heath Strange, the founder of Hampstead General Hospital.*

Fig. 65: The stonework plaque bearing the title of the hospital survives in the garden over the car park.

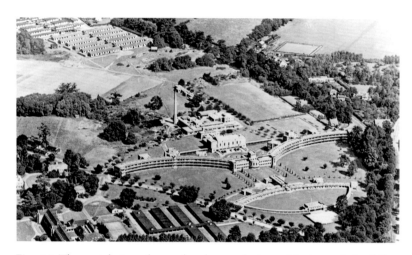

Fig. 66: The aerial view shows the elegant design with the main building crossbow in shape – a central block with curved, angled wings to either side of it.

When the No. 1 Australian Auxiliary Hospital closed at the end of the First World War, the Harefield Park estate was sold to the Middlesex County Council as a site for a tuberculosis sanatorium. The Australian huts were too close together for TB patients and most were demolished, but a few were reused in a different configuration. The Harefield Sanatorium opened in 1921 with 250 beds in six large wooden huts. Its kitchen garden and orchards provided fresh produce, as did its farm (geese, turkeys and 3,000 laying hens were kept, as well as pigs and a few goats). In the mid-1930s, the huts were replaced with permanent buildings, and the Harefield County Sanatorium opened in 1937 with 378 beds in two wings. At the outbreak of the Second World War, it became the Harefield Emergency Hospital, a base hospital for St Mary's Hospital (*see page 36*). Thirteen prefabricated huts of corrugated iron lined with asbestos were built, each containing twenty-four beds. Sixteen concrete huts with flat roofs were added in 1940. At its peak, the hospital had 1,200 beds.

In 1948, it joined the NHS as Harefield Hospital, a general hospital. By the 1960s, the farm had gone. While thoracic patients were still being treated in the early 1970s, the number of cardiac operations trebled. It became a world centre for heart and lung transplantation, including the first 'domino' heart transplant (i.e. a patient with diseased lungs receives a heart and lung transplant, donating their own heart to a person only needing a heart transplant). In 1998, it merged with the Royal Brompton Hospital. In 2003, the Anzac Centre opened, containing the Outpatients Department, the transplant clinic and two cardiac operating theatres.

*The hospital still specialises in heart and lung diseases.*

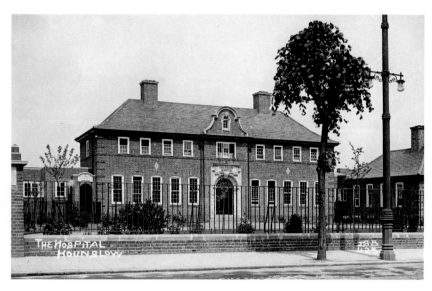

Fig. 67: The hospital was built in 1913 and later extended.

In 1875, a cottage hospital opened in Bell Road, Hounslow, founded by Dr L. de B. Christian. In 1913, it moved to a new purpose-built building with twenty beds in Staines Road. The hospital committee appointed a woman to act as a dispenser in the new hospital, an innovation at the time. During the 1920s, the hospital was extended and, in 1927, when it had fifty-four beds, a new Outpatients Department and X-ray Department were built. At this time it was dealing with a large number of road traffic accidents, mainly from the Great West Road. The nursing regime was strict. On the wards, breakfast had to be cleared away and the wards cleaned and put in order by 9 o'clock. In the evenings, patients had to be in bed by 8 o'clock. No member of the nursing or domestic staff was allowed to leave the premises without the matron's permission. The hospital became part of the EMS at the outbreak of the Second World War, when it had ninety-seven beds (thirty of which were EMS beds). At the end of the war, it had seventy-four beds and twenty-three EMS beds.

The hospital joined the NHS in 1948. By 1954, three single-storey wards (one each for men, women and children) had been added, after which it had eighty-one beds. In July 1961, a new Outpatients Department and Physiotherapy Department opened. The hospital closed in 1977, but the Health Service unions occupied the buildings for some weeks afterwards in protest against the withdrawal of services.

*The hospital was finally demolished during the late 1980s. The site is now a small retail park.*

# Mount Vernon Hospital
## Rickmansworth Lane, Northwood, Middlesex, HA6 2RN

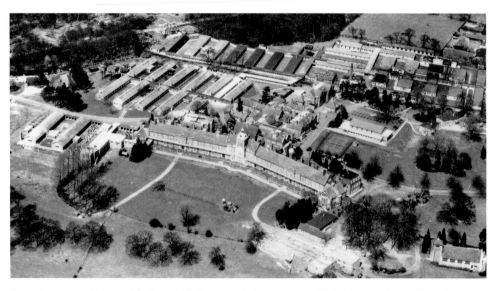

Fig. 68: An aerial view of the hospital showing the EMS huts built during the Second World War.

In 1902, the committee of the Mount Vernon Hospital for Tuberculosis and Diseases of the Lungs in Hampstead (*see p. 15*) purchased 60 acres of the Northwood Park estate to build a country branch. This opened in 1904. The hospital then had 250 beds at both sites. However, when local authorities began to provide TB sanatoria, this affected admissions and, in 1913, the Hampstead site was sold. In 1928, it became a general hospital, specialising in the treatment of cancer. As war loomed, ten EMS huts were erected in 1938 to accommodate 400 war casualties. During the war, it became the advanced base hospital for the Middlesex Hospital (*see p. 31*) for up to 1,000 patients. It was one of four national sites to store radium, with a well drilled to a depth of 15 metres for this purpose. By 1943, the hospital had 1,016 beds (including 946 EMS beds). After the war, it continued as a general hospital with radiotherapy and plastic surgery departments, but with a great shortage of nursing staff.

In 1948, it joined the NHS with 652 beds as the Mount Vernon Hospital and the Radium Institute. In 1968, new Outpatients and Accident & Emergency Departments opened. By 1970, some 90 per cent of the nurses and domestic staff were foreign-born. When the Accident & Emergency Department closed in 1997, the future of the hospital became uncertain. In 2006, the Plastic Surgery Unit merged with that at the Royal Free Hospital and relocated to the Hampstead site. A new £13 million Treatment Centre opened in 2009, which contains a new Outpatients Department, a Minor Injuries Unit, four operating theatres and wards for elective surgery.

*Today the hospital has 300 beds.*

# Neurorehabilitation Unit
## (National Hospital for Neurology and Neurosurgery)
### Great North Road, East Finchley, N2

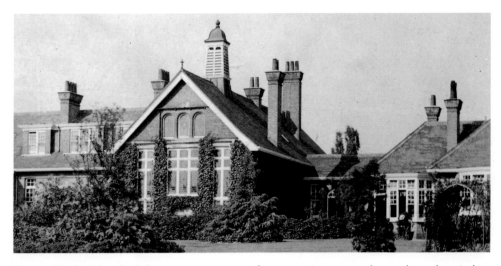

Fig. 69: The building had the appearance more of an attractive country house than a hospital.

In 1870, the management committee of the National Hospital for the Paralysed and Epileptic in Queen Square (*see p. 46*) decided to establish a country branch where female patients could be sent to convalesce (such was the popular fear of 'fits' that no convalescent home would accept epileptics). The Elms, a pair of semi-detached villas in East End Road, East Finchley, was chosen and the Convalescent Home opened in 1871 with twenty beds. By the mid-1890s, a larger building was needed and a field beside East Finchley station was leased on which to build a home. The purpose-built premises opened in 1897 with forty beds for women and children, all accommodated on the ground floor to aid wheelchair users and to avoid the hazard of a stairway for epileptic patients. The entrance hall was spacious and the walls were adorned with watercolour paintings of fruit and flowers. The grounds contained wide lawns, herbaceous flower borders, shrubberies, a fruit and vegetable garden, and newly planted specimen trees. Trees were also planted to screen the home from the railway. A rubbish-filled pond turned out to be a deep spring, one of the sources of the River Brent; this was drained and reshaped as a feature of the garden, with ferns, water lilies and carp, and weeping willows around the edge. By 1910, the home had thirty-six beds and cots.

The facility closed during the Second World War, but it joined the NHS together with its parent hospital in 1948. In 1967, it became its Rehabilitation Unit with twenty-five beds. It closed in September 1999.

*The home has been demolished, but the gatehouse survives. The site now contains a new gated residential estate – Bishops Park – and the Institute Arts Centre.*

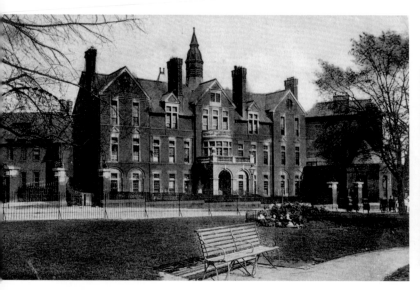

*Above left:* Fig. 70 A: The hospital around the turn of the century.

*Above right:* Fig. 70 B: The main entrance today with the Prince of Wales feathers at the top of the balcony.

The Evangelical Protestant Deaconesses' Institution and Training Hospital opened in a converted cottage in 1867. It had been founded by Dr Laseron so that ladies could be trained to nurse the sick poor. A city merchant donated a property (Avenue House on the east side of Tottenham Green), and the institution moved there in 1868. Avenue House was replaced in 1881 and extensions were added in 1887. The Prince and Princess of Wales (later King Edward VII and Queen Alexandra) opened the new buildings. In 1899, the voluntary Deaconesses were replaced by paid nursing staff. The institution became a general hospital and was renamed the Tottenham Hospital. In 1907, another extension was opened by the King and Queen and it became the Prince of Wales General Hospital. By 1923, it had 200 beds. On the staff at this time was a donkey, Nellie, who was a useful member of the institution as well as a great pet. In 1932, an outpatients wing was added and opened by the Prince of Wales (later King Edward VIII).

The Prince of Wales General Hospital joined the NHS in 1948 with 200 beds. However, by the early 1980s, 'closure by stealth' had begun, despite assurances from the Ministry of Health that this would not happen. By 1983, the hospital had largely closed.

*In 1993, the much-extended red-brick building was converted to provide apartments and renamed Deaconess Court.*

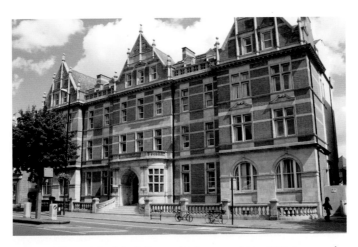

Fig. 71: The original building, which opened in 1888, is now the Northern Medical Centre.

The Great Northern Hospital was founded, at his own expense, by Dr Sherard Freeman Statham, an assistant surgeon, who had been dismissed from University College Hospital for smacking a patient's bottom. It opened in 1856 in York Road (now York Way) with sixteen beds. Soon two neighbouring houses were acquired, increasing the beds to fifty. The hospital was forced to move in 1862, and again in the 1880s. A site in Holloway Road was purchased in 1884 and the Great Northern Central Hospital opened in 1888 with sixty-eight beds. Further extensions were added over time and, in 1911, the word 'Central' was dropped from its title. An X-ray Department was installed in 1918. In 1921, when it had 110 beds, it amalgamated with the Royal Chest Hospital in City Road, becoming the Royal Northern Hospital. A convalescent home opened in Southgate (*see p. 58*) the same year. In 1922, a new Casualty Department, funded by the Islington War Memorial Fund, was built. A School of Radiography, one of the first in the country, opened in 1929. In 1931, St David's Wing opened. During the Second World War, both the Royal Northern and Royal Chest Hospitals received bomb damage, eighty-five beds being destroyed at the latter.

In 1948, it joined the NHS with 247 beds, merging with the Whittington Hospital in 1963. By 1980, it had 262 beds. However, during a period of amalgamation in the NHS, it lost out to the Whittington Hospital and closed in 1992.

*The building is now a medical centre. The rest of the site is occupied by an apartment block with the Grade II listed Islington War Memorial Arch incorporated into its side. A small park – the Royal Northern Gardens – contains a memorial wall with masonry from the hospital.*

# Uxbridge and District Hospital
## Harefield Road, Uxbridge, Middlesex, UB8 1PP

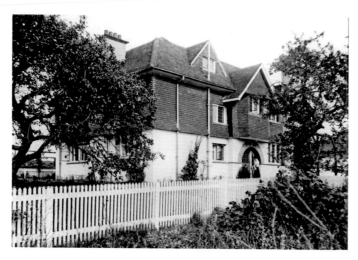

Fig. 72: The Cottage Hospital in Harefield Road.

After Florence Nightingale's success in nursing during the Crimean War, wealthy ladies began to take a philanthropic interest in medicine. In Uxbridge, Miss Laura Cox, the daughter of a local banker and landowner, campaigned for the establishment of a hospital for the area. The Cox family donated two small cottages in Park Road, and the Hillingdon and Uxbridge Cottage Hospital opened in 1869. In 1879, it moved to larger premises in Park Road. In 1914, it moved again, this time to Harefield Road. The Cox family, together with Lord and Lady Hillingdon and Lady Essex, had accepted financial responsibility for its equipping and staffing but, at the outbreak of the First World War, the Coxes moved away. The townspeople of Uxbridge then took on the maintenance of their 'community hospital'. A new wing was added in 1925, and another in 1929, when an operating theatre was installed.

In 1948, it joined the NHS as the Uxbridge and District Cottage Hospital, a GP hospital with twenty-four beds and Outpatients and X-ray Departments. In 1951, after a small children's ward was added, it had twenty-seven beds, six of which were kept for pre-convalescent patients from Hillingdon Hospital (the Cottage Hospital called these 'chronic beds'), and a further six for tonsil and adenoid cases. In 1961, the operating theatre was extended. By 1968, it had become the Uxbridge and District Hospital. In 1976, the Health Authority proposed to close it, but nothing happened until it was closed temporarily for refurbishment in 1978. The patients were moved to the Hillingdon Hospital (*see p. 22*). It was then decided to house its services in the specially named Uxbridge Ward at Hillingdon Hospital. It closed in 1978.

*The former hospital has been converted in a nursing home, Clare House.*

# Chapter 6

# North-East Metropolitan Region

This region covered north-east and east London, as well as parts of Middlesex, Essex and Hertfordshire.

During the late nineteenth century, several hospitals were built to the east of the City of London (the 'Square Mile') to serve an area engulfed by cheap, overcrowded housing for those working in London and its docks. Missions and settlements helped the poorest, many of them immigrants, living in the East End slums. The Quakers and the Salvation Army were active in this area too. All these groups established hospitals to provide free medical treatment.

By the twentieth century, the metropolis' suburban spread into rural Essex had created escalating health care problems, with little prior planning for the population. Rural towns, such as Enfield, Romford and Upminster had become sprawling urban centres. Ilford, in particular, had no hospital and no generous benefactor. As the town grew in size, the local population raised the money themselves.

By the end of the twentieth century, of the 112 hospitals in this region, some 70 per cent were still operational.

Fig. 73: Little patients in the Queen Elizabeth Hospital, Hackney Road. The legend on the tablecloth states 'Hunger is the best sauce'.

# Bethnal Green Hospital
## Cambridge Heath Road, Bethnal Green, E2 9NP

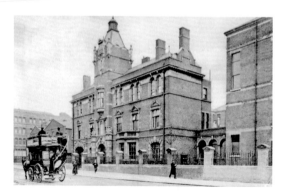

Fig. 74: Bethnal Green Military Hospital.

The Bethnal Green Infirmary opened in 1900 with 669 beds, mainly for the chronically ill. The military authorities took it over in 1915, and it became the Bethnal Green Military Hospital, with 709 beds. A wider range of services were added after the war, including an Orthopaedic Clinic, established at the request of the Ministry of Pensions, to provide treatment for ex-servicemen with damaged limbs. By 1929, Casualty and X-ray Departments had been opened and an operating theatre was being constructed. The LCC took control in 1930, when it had 650 beds.

In 1948, it joined the NHS as the Bethnal Green Hospital, a general hospital with just over 300 beds. A geriatric unit was established in 1954. The Obstetrics Department closed in 1972 and the Gynaecology department in 1974. From 1977, the role of the hospital changed from acute to geriatric care, but the Health Authority decided to close it. The staff 'occupied' the building as part of a campaign to protect its future, although the administrators moved out. While patients remained, the Health Authority was obliged to pay the medical and other staff, who continued to perform their duties. The surgical beds closed in June 1978, and the remaining medical beds in August. The hospital finally closed in 1990.

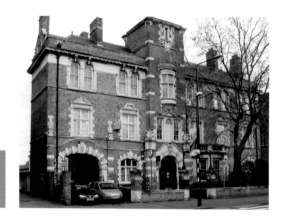

Fig. 75: The administration block was converted into apartments. All other buildings were demolished.

*The site is now a housing estate, which opened in 1993.*

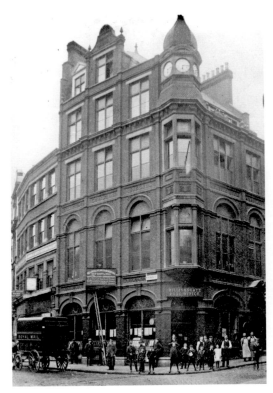
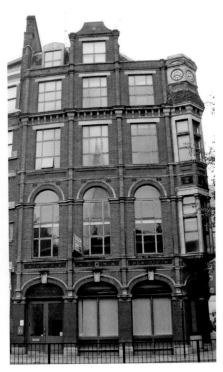

Fig. 76 : The red-brick building with its corner oriel at the turn of the century (*left*) and in 2012 (*right*). It presumably suffered damage during the Second World War – the top of the gable and the dome are missing.

The Billingsgate Christian Mission was founded in 1878, incorporating the humanitarian aims of the Billingsgate District Association with its own missionary work within Billingsgate Fish Market. It was predominantly funded by subscriptions and donations from companies and businessmen associated with the market. The building, opposite the market gates, opened in 1890. A dispensary was established in 1897. The enterprise was renamed the Billingsgate Christian Mission and Dispensary, providing free first aid to dock labourers, buyers, porters, salesmen and clerks working in or around the market. In 1905, an ophthalmic ward was opened. Clinics were held by surgeons on Tuesday evenings so that patients could be treated quickly without having to lose half a day's pay.

It did not join the NHS. Until the mid-1950s, nurses and those preparing to undertake missionary work abroad were trained at the hospital. Dockside deliveries to Billingsgate Market ceased in the 1950s, but the dispensary remained in operation until 1982, when the fish market was relocated to a new site in the Isle of Dogs. The Mission closed on 31 December 1990. The charity was handed over to the trusteeship of the Fishmongers Company in 1994.

# East End Maternity Hospital
## 384–398 Commercial Road, Stepney, E1 0LR

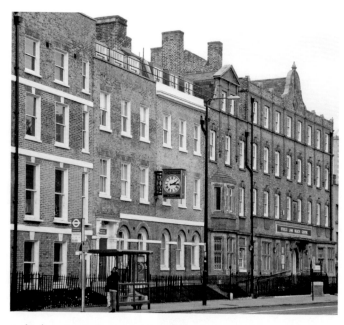

Fig. 77: No. 396, the first site, is the one with the blue door, with No. 398 to the left. The building at Nos 392–384, built in 1898, was listed Grade II in 1973.

The Mothers' Lying-In Home opened in 1884 in Glamis Road, Shadwell, with seven beds – the only maternity hospital for the whole of the East End, which contained a population of some 1 million. District nurses also attended women unable to leave their own homes. In 1889, the home moved to new premises at No. 396 Commercial Road, in the heart of the East End. It was renamed the East End Mothers' Home and had thirteen beds. Patients were admitted free of charge, usually remaining two weeks after delivery. In 1897, the premises were extended to eighteen beds, and to twenty-six beds in 1903. It was renamed the East End Mothers' Lying-In Home. In 1907, No. 398 was purchased to provide seven extra beds. In 1913, No. 394 was bought and finally opened in 1921, when the home had thirty-eight beds. The Needlework Guild provided each new baby with a trousseau (at least 800 were needed each year). In 1926, Nos 384–392 Commercial Road were purchased, giving a total of fifty-six beds. In 1928, it was renamed the East End Maternity Hospital. The LCC took it over in 1930. During the Second World War, the staff and patients were evacuated to Essex, and then to Buckinghamshire. In September 1940, the building was damaged by incendiary bombs during an air raid.

The hospital joined the NHS in 1948. It closed in 1968.

*The buildings survive, on the south side of the busy Commercial Road, as Steel's Lane Health Centre.*

# Forest Hospital
## Roebuck Lane, Buckhurst Hill, Essex IG9 5QN

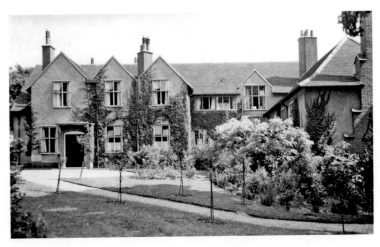

Fig. 78: The costs of the building were donated by a local family.

The Forest Hospital opened in 1913 with twenty-one beds. In 1921, it was extended to include three private patient rooms, new nurses' quarters and an X-ray room (the X-ray apparatus was installed in 1922). The female ward was also enlarged. The hospital then had forty beds. By the end of the decade, patients came from a wide area; the district covered a large acreage, but with no great density of population in any one location. Almost a third of admissions were accident cases. As the population increased, more patients were admitted and new staff appointed, causing overcrowding of the nurses' quarters, which were extended in 1935.

Forest Hospital joined the NHS in 1948 as a general hospital with forty-four beds. By 1960, it had been designated a General Practitioner Hospital. In 1977, it faced the threat of closure but, by 1985, had become a small, well-run hospital with thirty-five beds, a Physiotherapy Department, and a busy X-ray Department. Its day centre, with twenty places for elderly patients, provided a few hours' relief for their carers. But the hospital was again threatened with closure and this time it did not survive. It closed in 1986.

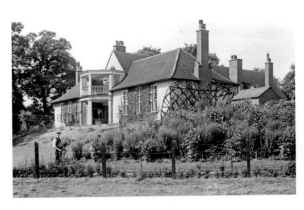

Fig. 79: The rear of the hospital.

*The building has been refurbished and extended. It is now Forest Place, a ninety-bed nursing care home for the elderly.*

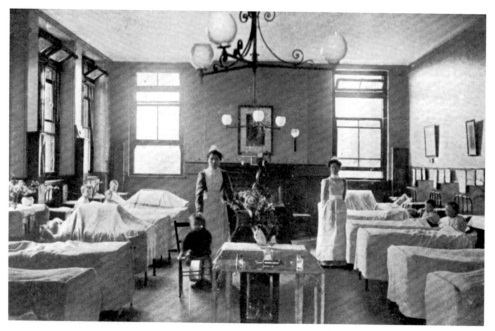

Fig. 80: The Gordon Ward.

Established by Dr Thomas Barnardo to care for the poor children of Stepney, Her Majesty's Hospital for Sick Children opened in 1888 with eighty-four beds. Built to mark Queen Victoria's Golden Jubilee in 1887, it was one of the first hospitals to specialise in children's illnesses, and was the largest such hospital in London at that time, with six general wards, isolation and convalescent wards, as well as an operating theatre. The resident physician's apartment opened cabin-like onto an asphalted flat roof, which was used as an open-air exercise yard by convalescents. The basement, connected to Dr Barnardo's Boys' Home by a tunnel, contained a kitchen, a dispensary and a mortuary (although the hospital had a low mortality rate because of its high standards of hygiene). In 1903, No. 30, on the other side of the railway, was purchased for an isolation ward. By 1905, the hospital had ninety cots and beds. It closed in 1922, as most of the children had moved to new accommodation in the William Baker Technical School in Hertford. Its work was taken over by the John Capel Hanbury Hospital in the Boy's Garden City, Woodford Bridge.

*The building was renamed Barnardo House and used as office accommodation until 1969. The area has since been redeveloped and the hospital site is now part of the Pitsea Estate, a housing complex. Barnardo Street runs into Stepney Causeway.*

# Honey Lane Hospital
### Honey Lane, Waltham Abbey, Essex, EN9 3AZ

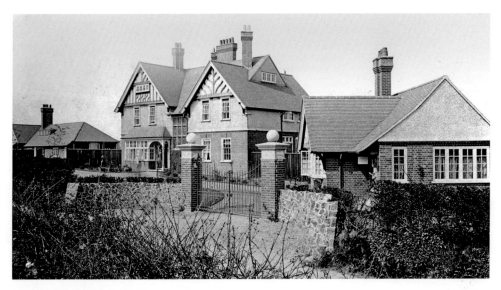

Fig. 81: The Waltham Abbey Isolation Hospital cost £7,100 to build.

The Waltham Abbey Isolation Hospital opened in 1908, with twenty-four beds in three ward blocks grouped around a small lawn behind an administration building. The wards had no skirting boards and all corners to the rooms were rounded, so as not to harbour dust and dirt. Four acres of the 10-acre site were given over to agricultural use and sewage disposal (there was no access to the mains and effluent sewage was treated using septic tanks and a bacteria bed with revolving sprinklers). During the First World War, some thirty-two beds were reserved for military patients. New buildings were added during the 1930s.

It joined the NHS in 1948 as a well-equipped modern hospital, but only forty of its 130 beds were staffed. Immunisation had made diphtheria rare and, in 1951, three ward blocks (seventy-eight beds) were designated for female TB patients. In 1952, it was renamed Honey Lane Hospital. In 1957, as the incidence of pulmonary TB had fallen, six medical beds were designated for neurological patients. A Physiotherapy Department was established for recovering polio patients during the 1950s. In the early 1960s a Regional Maxillofacial Unit was set up. In 1974, the hospital had 106 beds for diseases of the chest, oral surgery, medical and neurological cases. By 1982, it had seventy-three beds for mainly long-stay patients and GP cases. It closed in 1986.

*The site was sold for £20 million. The hospital buildings were demolished and new houses and roads built. However, part of the site contains a large, low-rise unit, the Honey Lane Residential Dementia Care Home.*

# Ilford Emergency Hospital
## Abbey Road, Newbury Park, Essex

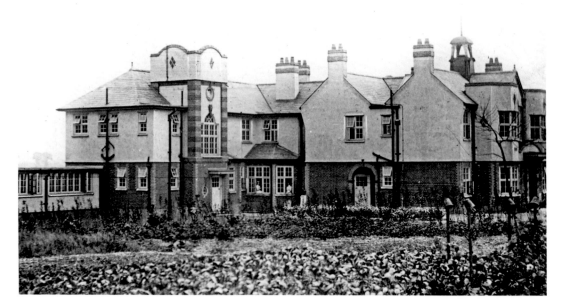

Fig. 82: During the First World War, from May 1915 until March 1919, it became a military hospital.

The Ilford Emergency Hospital opened in 1912 with twenty beds. In 1920, it was extended to forty-two beds. In 1921, the LCC built the Becontree Estate on 300 acres of wasteland near Dagenham. Planned to eventually accommodate some 120,000 people, it was the largest housing estate in the world. Sites for a hospital and other amenities had been provided in the initial layout but, as the building scheme developed, 'the best-laid schemes o' mice an' men gang aft agley'. The LCC considered it had fulfilled its role as a landlord by providing new housing, and that the provision of any further infrastructure was the remit of Essex County Council. In 1923, a fund was inaugurated for a voluntary hospital to serve the half million residents of Thameside East. While debate raged as to a suitable site, the only acute inpatient facilities available were at the Ilford Emergency Hospital, which was extended again in 1925 to fifty-four beds. In 1926, the War Memorial Children's Wing with ten beds was built beside the town's war memorial and its garden, opening in 1927. By this time, the scheme to build a hospital at Becontree had collapsed and it was decided to rebuild a larger one on the Ilford site. It would front Eastern Avenue and be known as the King George Hospital (*see p. 77*).

*The buildings were later demolished and their site occupied by the King George Hospital. Only the Memorial Hall, originally intended to be the entrance to the new Children's Wing (but never used) survives.*

# Invalid and Crippled Children's Hospital
119 Balaam Street, Plaistow, E13 8AF

Fig. 84: A postcard of the hospital dated 1909, before it was renamed in 1923.

The hospital was founded in 1893 by the London Medical Mission Association, but was taken over by the Canning Town Women's Settlement the following year as a hospital for women and children. It moved to Balaam Street in 1905. In 1914, the Invalid and Crippled Children's Society was formed to provide health and welfare services in the south half of West Ham. In 1923, the twenty-six-bed hospital in Balaam Street was conveyed rent-free by the Canning Town Women's Settlement to the South West Ham Invalid and Crippled Children's Society, on the understanding it would be used for children only. The building was extended in 1932, with a new Outpatients Department being added and, in 1933, an open-air ward. The hospital then had thirty-six beds. During the Second World War, only one ward was kept open. Although the building suffered some bomb damage, there was no direct hit.

The hospital reopened fully after the war and, in 1948, it became part of the NHS. During the 1960s, it specialised in orthopaedic surgery for children and women, as well as surgery for ear, nose and throat conditions, for example, removal of tonsils and adenoids. In 1970, the hospital had thirty-three beds. It closed in 1976, along with many other small hospitals, following reorganisation of the NHS.

*The building has been demolished. New housing has been built on the site, but the original wall has been retained.*

# Ivy House
## 271 Mare Street, Hackney, E8 1EE

Fig. 85: Ivy House, on the corner of Mare Street and Richmond Road, was a large four-storey building with a three-storey annexe. Prior to it being rented by the Salvation Army, it had been a lodging house.

In 1886, the Salvation Army opened Brent House in Hackney, its first rescue home in the area for unmarried mothers, but this soon became inadequate and nearby Ivy House was rented. This opened in 1890 with twenty-one beds and a training school for midwives. The gaslit building had wards on the first and second floors, with a toilet (also used as a slop sink) on the half-landing between. In 1894, the rescue work moved and Ivy House temporarily closed, although the district midwife service continued (the nurses combined attending childbirth with evangelising the patients). The nursing staff moved into the house next door (No. 225 Richmond Road), and the home soon reopened as the Salvation Army's first dedicated maternity hospital for unmarried mothers. Most patients were aged between fifteen and twenty years, and had led respectable lives before being abandoned by their lovers when they fell pregnant. By 1906, the hospital had six wards with a total of twenty-two beds, but no bathrooms; moveable baths were provided in the wards and the antenatal room. An isolation ward, detached from the main buildings, was erected against the external wall of No. 225, which now also housed those waiting cases who provided domestic help in the hospital. By 1912, two private rooms for married women were available. Ivy House closed in 1913, when the newly built Mothers Hospital opened (*see p. 80*). During its operational lifetime, some 4,500 babies had been delivered.

*The building was demolished shortly after the hospital closed. Its site is currently occupied by Jobcentre Plus.*

# King George Hospital
## Eastern Avenue, Ilford, Essex, IG2 7LR

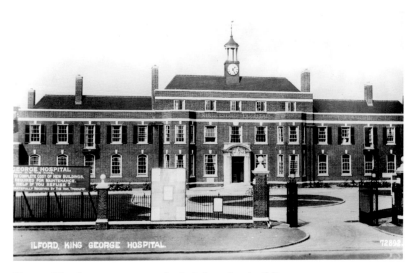

Fig. 86: The front entrance and administration building.

The King George Hospital was officially opened by the King himself in 1931. Two new wards of fifty-four beds were added in 1932, while two obsolete wards of the Ilford Emergency Hospital (*see p. 74*) closed. The hospital then had 142 beds. In 1934, a department for radiation treatment was established. The Baker Memorial Wing opened in 1935, with private rooms and a solarium on the ground floor, and a large public ward with thirty-four beds on the first floor. The hospital was also extended, after which it had 207 beds.

In 1948, it joined the NHS with 228 beds. In 1952, a new Outpatients Department opened, but the architect had forgotten to include patients' changing rooms; these had to be built at the end of a passage. In 1955, the electricity supply was changed from direct to alternating current, an urgent necessity as all modern hospital apparatuses were run on the latter. The hospital had become overcrowded and the Casualty Department, which received all accident cases from the A12, was castigated in the press as a 'disgrace'. Despite this, it managed to treat 35,000 patients in 1956 in a small hall measuring 6 metres by 6 metres. In 1957, the hospital was modernised. By the late 1960s, its 7-acre site was deemed too small to be redeveloped as a district general hospital and the possibility was raised of rebuilding it adjacent to Goodmayes Hospital (*see p. 120*). In 1974, it had 203 beds. In 1978, the Ilford Maternity Hospital became its West Wing. It closed in 1993, when the newly built King George Hospital opened on the Goodmayes Hospital site.

*The hospital was demolished in 2001. The site is now occupied by a housing development.*

# London Chest Hospital
Bonner Road, Victoria Park, E2 9JX

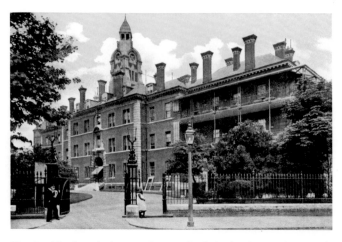

Fig. 87: The hospital around 1905, built in the Queen Anne style.

The City of London Hospital for Diseases of the Chest opened in 1855. The south wing was completed in 1865 and the final wing in 1871. It then had 164 beds, mainly for patients with tuberculosis whose treatment was limited to simple bed rest and nourishing food. By the turn of the century, fresh air was also considered necessary and balconies were added to the wards so that patients could lie in the open air. The central heating system was not used and the ward windows were kept wide open. During the First World War, when the hospital had 178 beds, it received injured and gassed servicemen from the Western Front. Renamed the City of London Hospital for Diseases of the Heart and Lungs in 1923, it was known popularly as the 'Victoria Park Hospital'. In 1937, it was renamed again, becoming the London Chest Hospital. During the Second World War, half the beds were given over to the EMS. Badly damaged by bombs in 1941, the hospital remained open throughout the war, with the public funding any necessary repairs.

In 1948, it joined the NHS as a teaching hospital with 135 beds for patients with heart and lung conditions.

Fig. 88: Today the building appears little changed, although the central tower is reduced in size following bomb damage. The ward balconies have been enclosed.

*The hospital continues to develop specialised units, such as the Heart Attack Centre.*

# Mile End Hospital
## 275 Bancroft Road, Stepney, E1 4DG

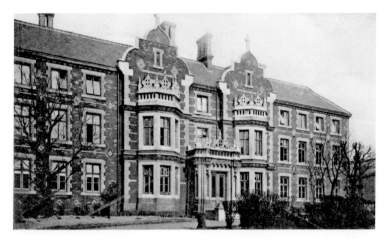

Fig. 89: The hospital was previously a workhouse.

In 1858/59, a new workhouse and infirmary was built to the north of Mile End Road, with a new road – Bancroft Road – laid to provide access to it. In 1883, a new infirmary was built on the site of the old infirmary and imbecile wards. The Mile End Old Town Infirmary consisted of three parallel three-storey blocks – the central one used for administration and services, with the male and the female wards either side. During the First World War, it became the Mile End Military Hospital and its facilities were greatly improved. In 1930, it came under the control of the LCC, who renamed it Mile End Hospital.

It joined the NHS in 1948 with 550 beds. In 1968, the London Hospital took over its management and it became the London Hospital (Mile End). In 1990, the Bancroft Unit for the Care of the Elderly opened. In the same year the London Hospital was granted a Royal title so, as part of the group, it was renamed The Royal London Hospital (Mile End). In 1994, it reverted to the name of Mile End Hospital.

Fig. 90: The back of the workhouse buildings showing the nurses' home, the infirmary and the laundry.

*It is now a community hospital and cares mainly for elderly patients. The £35 million two-storey Tower Hamlets Centre for Mental Health, with 114 beds, opened in 2007.*

# The Mothers' Hospital of the Salvation Army
### 153–156 Lower Clapton Road, Hackney, E5 8EN

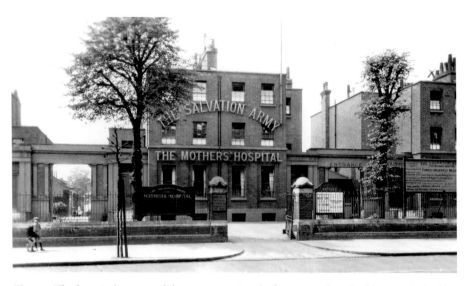

Fig. 91: The hospital's unusual frontage consisted of six semi-detached houses linked by two distinctive arches giving access to the ward buildings behind. The central two bore the name of the hospital in large lettering.

When Ivy House (*see p. 76*) became overcrowded, the Salvation Army bought a site in Lower Clapton Road for a maternity hospital. The Mothers' Hospital opened in 1913 with forty-eight beds in four single-storey buildings, erected in the gardens of the houses. Each contained three wards (furnished with a portrait of the late General Booth and his wife), a delivery room, and a kitchen and bathroom. All senior nurses were officers in the Salvation Army. During the First World War, pregnant widows (and later wives) of servicemen were admitted. After the war, all mothers, married or not, were accepted. By 1921, the hospital had seventy-two beds. An Outpatients Department opened in 1934, and in 1937 a new isolation block was established. During the Second World War, the hospital was allowed to remain open, on condition that an air-raid shelter was built. Until this was ready, patients remained in their wards during bombing raids, singing hymns to keep their spirits up. In September 1940, two ward blocks were destroyed by a direct hit from a bomb, but there were no casualties. The bomb shelter was completed a month later, and only those in labour were allowed to remain in the hospital itself in a specially reinforced labour room. The damaged ward blocks reopened in 1946. The hospital joined the NHS in 1948. The legend on the central house was changed to 'The Mothers' Hospital (Salvation Army)'. Salvation Army members were still welcomed on the staff, and this relationship between the NHS and Salvation Army continued until closure of the hospital in 1986, when Homerton Hospital opened.

*The ward buildings have been demolished and replaced by a housing complex – Mothers' Square. The frontage remains substantially intact.*

Fig. 92: The hospital, with what looks like an empty lot in front of it awaiting development.

The Plaistow Hospital originated on the sites of three hospitals. In 1894, the West Ham Borough Council bought the Poplar Board of Works Infectious Diseases Hospital in Samson Street (opened in 1871); the neighbouring Smallpox Hospital in Pragel Street subsequently closed. A year later, the West Ham Board of Guardians Smallpox Hospital in Western Road, which had also opened in 1871, was purchased. A large island site was thus available for a new infectious diseases hospital. This opened in 1901 as the Plaistow Fever Hospital, with 210 beds. It was one of the most modern of its kind, pioneering the barrier method of nursing infectious patients. It played a role also in the training of medical students. During the Second World War, the hospital suffered bomb damage.

It joined the NHS in 1948 as the Plaistow Hospital, treating acute medical cases as well as infectious diseases patients. In 1983, it became a hospital for elderly long-stay patients but, by the turn of the century, they occupied just half the site. The hospital was no longer deemed economically viable, and it closed in 2006. The patients were transferred to the newly opened, purpose-built East Ham Care Centre, behind the East Ham Memorial Hospital in Shrewsbury Road.

*The 2.9-acre site remained vacant until 2011, when it was sold to Peabody. It is currently being redeveloped (2014). All but five Victorian buildings have been demolished.*

Howards Road Lying In Hospital, Plaistow

Fig. 94: Nurses gathered in front of the hospital.

In 1886, the vicar of St Mary's, Thomas Given Wilson, founded a welfare clinic and a day nursery in London Road, Plaistow. In 1889, one of its nurses, Miss Katharine Twining, established St Mary's Nursing Home in Howards Road to provide midwifery and nursing support to the poor in their own homes. In 1894, two houses (Nos 17 and 19 Howards Road) were purchased for the District Nurses' Home. Midwifery and District Nursing Training Schools were established. The premises were extended in 1898. In 1904, two more houses (Nos 24 and 26 Howards Road) were acquired for twelve inpatient beds. By 1911, after No. 28 Howards Road was purchased, the home had twenty beds. In 1915, Chesterton House was bought, becoming a centre for antenatal and postnatal care. A new building in Chesterton Road was opened by Queen Mary in 1923. This became the inpatient building, with thirty-six maternity and four general beds. In 1926, the home was renamed Plaistow Maternity Hospital. In 1929, it was further enlarged to sixty beds. By the 1930s, it had become an outstanding centre for the training of midwives. During the Second World War, it was damaged by bombing. Inpatients were evacuated to Suntrap, a house at High Beech, near Loughton, Essex.

The hospital joined the NHS in 1948. In 1976, the Local Health Authority decided to close it and services were transferred to Newham Maternity Hospital, pending the building of the new Newham General Hospital.

*The hospital buildings have been demolished and new housing occupies the site.*

# Poplar Hospital
## 303–315 East India Dock Road, Poplar, E14 0HP

Fig. 95: The sign on the hospital wall requests that 'Drivers kindly walk past hospital'.

The Poplar Hospital for Accidents ('Dockers' Hospital') opened in 1855 with twenty beds to treat workers injured in the East and West India Docks (and later Millwall Dock). Prominent in its establishment – after a seriously injured labourer died on the way to the London Hospital (the nearest to the docks) – were Samuel Gurney, a Quaker banker, and Money Wigram, a shipbuilder and ship owner. In 1870, the hospital began to accept medical cases. Much extended from 1880 to 1899, it began to provide general treatment, and to admit women and children. In 1910, some 345 workmen, injured during the building of the *Thunderer*, a Dreadnought-class battleship, at the Thames Iron Works, received treatment. In the First World War, the buildings were badly damaged by bombs during Zeppelin raids. In January 1917, the hospital overflowed with the injured from the Silvertown explosion, when 50 tons of TNT exploded at Brunner Mond's chemical works. Sixty-nine people were killed and 450 injured. After the war, the hospital was much extended and improved. In 1937, the words 'for Accidents' were dropped from its name as it had long been a general hospital. During the Second World War, the original main building was destroyed by bombing in 1941. A number of people were killed and the hospital was forced to close for a short time.

In 1948, it joined the NHS with 120 beds. By 1950, the original hospital had been mainly replaced by more functional buildings, but the decline of the inner London docks rendered it obsolete. It closed in 1975 with 105 beds. Despite protests from the local residents, who wanted to keep the buildings for community use, it was demolished in 1982.

*The area has been completely redeveloped, with new roads and housing now occupying the site.*

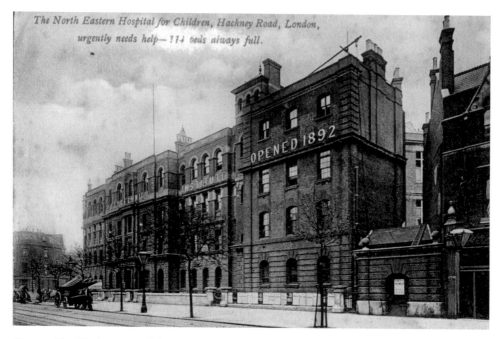

*The North Eastern Hospital for Children, Hackney Road, London, urgently needs help— 114 beds always full.*

OPENED 1892

Fig. 96: The Hackney Road frontage. During the late nineteenth century, new ward buildings were added and the hospital was greatly expanded. It then had 114 beds.

In 1867, in the wake of a cholera epidemic, two Quaker sisters founded the Dispensary for Women and Children in Bethnal Green. The work was transferred shortly after to a house in Hackney Road. It became the North Eastern Hospital for Children, with twelve cots. In 1870, the hospital moved to a building on the corner of Hackney Road and Goldsmith Row.

In 1907, it was renamed the Queen's Hospital for Children. In 1911, a country branch for convalescent children was established in Bexhill-on-Sea. In 1938, a new Outpatients Department opened. In 1942, it amalgamated with the Princess Elizabeth of York Hospital for Children in Glamis Road, Shadwell, to form the Queen Elizabeth Hospital for Children. A country branch in Banstead, Surrey, opened in 1946. A Hospital Management Committee, formed in 1948 at the founding of the NHS, administered the three sites. The Shadwell branch closed in 1963, and the Hackney Road branch in 1996 (Banstead in 1998). Services were relocated to the Royal London Hospital and the Hackney Road buildings became vacant.

*In 2014, the 1.6-acre site remains vacant, awaiting redevelopment into housing. It is proposed that the two main façades will be preserved.*

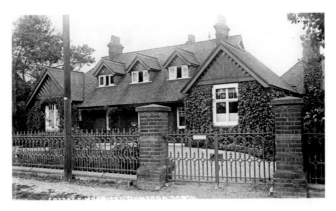

Fig. 97: The hospital was built in commemoration of Queen Victoria's Jubilee. It dealt mainly with non-infectious cases of curable disease and accidental injuries.

The Victoria Cottage Hospital opened in Pettit's Lane in 1888 on a site donated by William Mashiter, a member of a prominent Romford family. It was enlarged in 1893, giving a total of thirteen beds. In 1901, a new wing was added, which included an intensive care ward for severely injured patients, making it one of the most up-to-date cottage hospitals in the country. It was further extended to seventeen beds in 1912 to commemorate the death of King Edward VII. In 1924, further additions were made and a children's ward opened in 1925, to give thirty-three beds. In 1939, work began on a three-storey building on the north part of the site.

In 1948, it joined the NHS with 101 beds. The children's ward closed in 1978. The hospital became run-down and neglected and, in 1979, despite local opposition, the Health Authority proposed to close it and convert it to other uses, such as a psychogeriatric day unit and offices for community health staff. By 1982, it had only thirty-two beds. The wards closed in 1985, but the Outpatients Department continued until 1989.

*It is now the Victoria Centre, housing various NHS health care services, and Crossroads Care Havering, a charitable organisation providing respite care for long-term carers.*

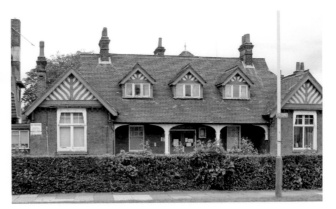

Fig. 98: The rather pretty original hospital building is still in use, but appeared somewhat run-down in 2009.

The West Ham Infirmary opened in 1903 with 672 beds. In 1917, a 240-bed section became the Whipps Cross War Hospital. After the war it became a general hospital and was renamed Whipps Cross Hospital. In 1930, it came under the control of the West Ham Borough Council, who added more ward blocks. During the Second World War, the hospital joined the EMS, with 388 of its 744 beds reserved for civilian air-raid casualties.

It became part of the NHS in 1948, with 1,044 beds. In 1955, a new entrance was built. An Outpatients Department opened, somewhat belatedly, in 1958. By the end of the 1950s, as the number of cars increased, visitors were no longer allowed to park in the grounds because emergency ambulances were unable to get through. In 1965, a Medical Education Centre opened, one of the first in England. An Intensive Care Unit opened in 1968, as did a Hyperbaric Unit. The Maternity Wing opened in 1973. In 1976, the hospital had 960 beds, mainly for acute patients. By 1997, it was in deep financial crisis, with a deficit of £4 million. Nevertheless, work began in 2011 on a new £23 million Emergency and Urgent Care Centre, which opened in 2012. Because of continuing financial problems and uncertainties over its future, a scheme for redevelopment of the site was abandoned.

*In 2012, the hospital became part of the Barts Health NHS Trust.*

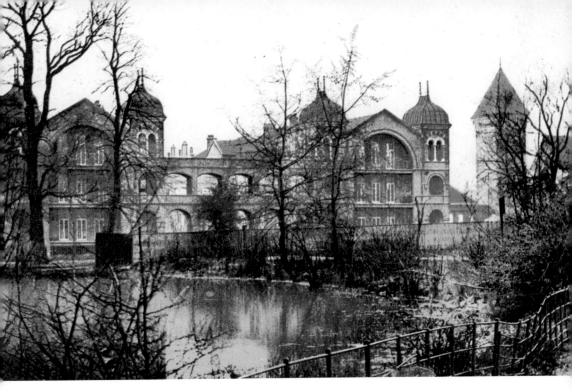

*Above:* Fig. 99 A: An undated postcard of the West Ham Infirmary; the pond in the foreground was filled in after a nurse drowned in 1949.

*Below:* Fig. 99 B: Aerial view of the Hospital in the 1930s. The central administration building was flanked by two massive towers, with two symmetrical three-storey ward blocks on either side (male wards on the right and female on the left) linked by tiered covered walkways at each level.

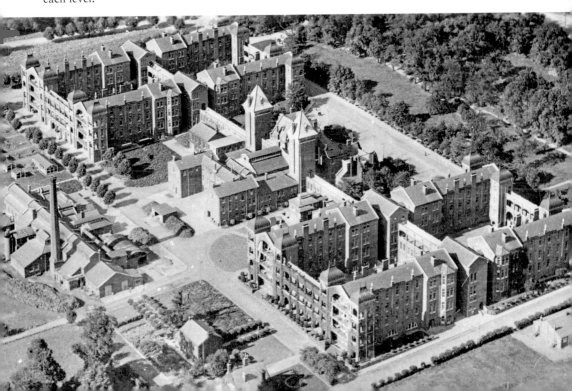

# Chapter 7

# South-East Metropolitan Region

This region contained hospitals in south-east London and much of Kent.

From 1883, smallpox patients were taken to two hospitals ships moored at Long Reach, near Dartford, 17 miles from London. These old wooden warships, chartered from the Admiralty by the Metropolitan Asylums Board, had previously been moored at Greenwich. The iron paddle steamer *Castalia* joined them in 1884. The three ships were moored in a line about 50 metres from the shore, but unconnected to it. They were joined to each other by a complicated gangway, which allowed for the rise and fall of the tide and for slight sideways movement of the vessels. Wharves were built at Rotherhithe, Poplar and Fulham to collect the patients to be transported by the River Ambulance Service to Long Reach. In 1902, land hospitals replaced the ships (*see p. 95*).

Until the 1970s, the Thames had been a working river with ships bringing cargoes to the docks of London. Several hospitals had been established near the river to deal with sick or injured dock workers and seamen, but the decline in the amount of shipping using the Thames during the latter half of the twentieth century resulted in fewer patients. By the 1980s, the docks had closed and trade had moved downriver to Tilbury and beyond.

By the end of the twentieth century, more than half of the hospitals in this region had closed.

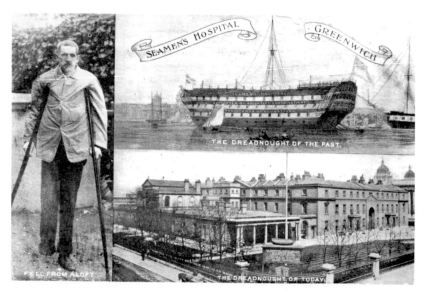

Fig. 100: The original Seamen's Hospital, founded by the Seamen's Hospital Society in 1821, had been on board various former naval ships. It moved to dry land in 1869, taking over the infirmary of the Greenwich Hospital (*see p. 12*).

# Bromley Hospital
## 17 Cromwell Avenue, Bromley, Kent BR2 9AJ

Fig. 101: In 1897, the hospital consisted of a single much-extended building.

In 1869, Dr Walter Thomas Beeby, a local GP, formed a committee to establish a cottage hospital. Two small cottages were purchased in Pieter's Lane (now Cromwell Avenue), and the Bromley (Kent) Cottage Hospital opened the same year with six beds. The cottages were demolished in 1875 and a new hospital built. By 1886, it had twenty beds. In 1897, a new wing with fourteen beds was added. By 1910, the hospital had forty-two beds. During the First World War, twenty beds were reserved for military cases, occupied first by wounded Belgians in October 1914. In 1928, it was renamed the Bromley (Kent) and District Hospital. More extensions opened in 1931, but the haphazard additions made it difficult to extend the building sensibly. As it was near the main road to the South Coast, it was dealing with a rising number of road traffic accidents and, in 1934, an adjacent cottage was bought for further extension. In 1936, when it had ninety-six beds, it was renamed the Bromley and District Hospital. During the Second World War, ten extra beds were added to each ward for anticipated air-raid casualties. After the war, when a Rehabilitation and Occupational Therapy Centre opened, it was regarded as one of the finest GP hospitals in the country, in the vanguard of providing rehabilitative as well as acute care.

It joined the NHS in 1948 with 187 beds in a hotchpotch of buildings added at different times, some well-built in brick, others temporary wooden huts, private houses and odd sheds. Plans were made in 1966 to rebuild it with 400 beds, but there was no money. By 1990, it was known as Bromley Hospital, an acute hospital with 170 beds. It closed in 2003 and services were transferred to the newly built Princess Royal University Hospital at Locksbottom.

*The site was sold and the hospital demolished. A large housing estate – Reflex Apartments – has been built in its place.*

Fig. 102: The Brook War Hospital with the porter's lodge between two entrances.

The Brook Fever Hospital, opened by the Metropolitan Asylums Board in 1896, had 488 beds. Designed to separate infectious areas from the non-infectious, it had two entrances, with a porter's lodge in between – the eastern one for admissions and the western for the 'non-infectious'. The 29-acre site contained forty separate blocks, the main ward pavilions being connected by roofed walkways. The wards had low window sills (75 cm from the floor), enabling patients to see out, and wide balconies, where they could be nursed in the open air. During the First World War, it became the Brook War Hospital with 1,000 beds. Two operating theatres and an X-ray room were installed. In 1921, the hospital had 580 beds but, as infectious diseases had declined, many remained empty. In 1930, it was taken over by the LCC. During the Second World War, it became a general hospital, treating many air-raid casualties. Some buildings were destroyed by bombs.

It joined the NHS in 1948 as the Brook General Hospital with 472 beds. The wards, built to take twenty fever patients, now contained thirty beds, but the overhead lights, set at fever bed distances (3.5 to 4.5 metres apart), meant that not every bed had a light. Most patients were long-term, and additional beds had to be set up in the middle of the medical wards. The Regional Thoracic Surgery and Neurosurgery Units were located at the site. An A&E Department opened in the 1960s, built where two ward blocks had been destroyed during the war. The hospital closed in 1995, when the Queen Elizabeth Hospital opened in Woolwich.

*The ward blocks have been demolished but some small buildings remain. The water tower, which once contained an 80-ton cast-iron water tank, has been converted into a modern dwelling. The site now contains luxury apartment blocks – Brook Village.*

# Cray Valley Hospital
Sandy Lane, St Paul's Cray, Orpington, Kent, BR5 3HY

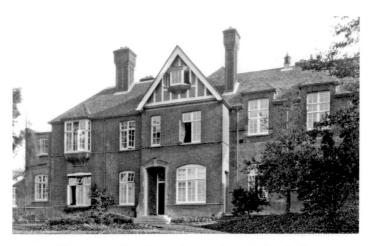

Fig. 103: The Cray Valley Hospital was substantially rebuilt in 1924.

The Chislehurst, Sidcup and Cray Valley Cottage Hospital opened in 1884, having been established by the area's Medical and Surgical Aid Society. By the 1930s, it was known variously as the Chislehurst, Orpington and Cray Valley Hospital or, more simply, as the Cray Valley Cottage Hospital. In 1938, it had thirty beds. During the Second World War, it joined the EMS, with thirty-five beds under the control of Guy's Hospital.

It joined the NHS in 1948 as a GP hospital with thirty-one beds. It closed in 1974, when new ward facilities were made available for GPs at the newly rebuilt Queen Mary's Hospital in Sidcup. However, the Regional Health Authority agreed that the building could be used as a temporary smallpox isolation unit until a new unit was built at Joyce Green Hospital (*see p. 98*) (the usual smallpox facility, Long Reach Hospital, was being demolished for work on the Thames Barrier). Some £15,000 was allocated to the conversion of Cray Valley Hospital, and the local authorities agreed to close part of the road leading to the hospital, should the need arise. Although it never seems to have been used, the building remained available as a smallpox facility until 1979, although the work at the Joyce Green Hospital was completed early in 1977.

Fig. 104: The original building still exists.

*The building is now part of a leisure complex.*

# Dulwich Hospital
## East Dulwich Grove, SE22 3PT

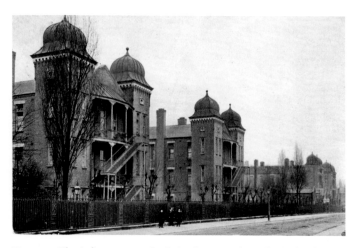

Fig. 105: The infirmary was built in the typical pavilion plan layout with a French-style chateau two-storey central administration block and a pair of double three-storey ward blocks on each side.

St Saviour's Union Infirmary opened in 1887, with 723 beds in twenty-four Nightingale wards of about thirty beds each. In 1902, it was renamed the Southwark Union Infirmary. During the First World War, the War Office asked for permission to use Poor Law Infirmaries for the alarming number of casualties. It was the first in London to be evacuated, becoming the Southwark Military Hospital from 1915 until 1919, with tents erected in the grounds to increase the bed number to 820. In 1921, it became the Southwark Hospital, a general hospital, until 1931, when the LCC took it over and renamed it Dulwich Hospital. The ground floor wards were converted to an Outpatients Department, offices and laboratories, after which it had 423 beds. During the Second World War, it treated local civilian air-raid casualties and, although bombs exploded nearby, its buildings did not receive a direct hit.

In 1948, it joined the NHS. It became a District Hospital with a centre for renal treatment, but the A&E Department closed in 1964. In 1984, St Francis' Hospital, originally the Constance Road Institution of the Camberwell Union, became its North Wing; a subway was built under the railway to link the two sites. At this time the South Wing had 295 beds, while the North Wing had 187 beds, mainly for acute geriatric patients. In 1988, a new £1 million renal ward opened, the money being raised locally over five years. The hospital closed in 2005, and acute services transferred to King's College Hospital (*see p. 30*).

*A new community hospital opened in 2007 in the administration block. The western pavilions are also in use for health care services but the eastern ones have been demolished. The North Wing (St Francis' Hospital) site has been redeveloped for new housing.*

# Livingstone Hospital
## East Hill, Dartford, Kent, DA1 1SA

*Above left:* Fig. 106 A: The hospital opened in 1894.

*Above right:* Fig. 106 B: The entrance door with the foundation stone in commemoration of Dr David Livingstone above.

In 1880, the pharmacist and philanthropist Silas Burroughs and his friend, Henry Wellcome, set up a pharmaceutical company, Burroughs Wellcome & Co. (now part of GlaxoSmithKline). The firm soon needed larger factory space and, in 1889, they purchased the site of the Phoenix Paper Mills in Dartford. Burroughs took an interest in the health and welfare of his employees, and fought hard to establish a local hospital for them in Dartford, despite difficulties in obtaining land. In April 1894, the journalist Henry Stanley laid the foundation stone for the new hospital. Burroughs had requested that it be named in memory of the missionary and explorer David Livingstone. The Livingstone Cottage Hospital opened later the same year – the only general hospital in Dartford until 1913, when the old infirmary at the Dartford Union workhouse became the King Edward Hospital (later West Hill Hospital). By 1928, the hospital had forty beds. In 1938, a new maternity wing opened.

The hospital joined the NHS in 1948 with fifty-two beds. Although plans were made for its redevelopment, these never materialised and it became a community hospital with two wards in 1997. From 2003, it has been used as a rehabilitation unit for elderly patients.

*The hospital has twenty-eight beds, but despite its care being singled out for praise, the buildings are considered out-of-date and too costly to refurbish. Its future remains uncertain.*

# Queen Mary's Hospital
## Frognal Avenue, Sidcup, Kent, DA14 6LT

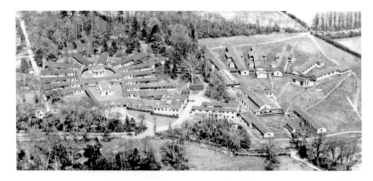

Fig. 107: The Queen's Auxiliary Hospital at Frognal consisted of wooden huts, built in five months.

By 1915, the wartime need for a specialist unit to deal with maxillofacial injuries had become apparent. Frognal House and its grounds were purchased by the government and the Queen's Auxiliary Hospital opened in August 1917 with 300 beds – fifteen for officers and 285 for other ranks. It became the central military hospital for reconstructive surgery following facial and jaw injuries, not only for the United Kingdom, but for all the Imperial Expeditionary Forces, with separate units for Canadians, Australians and New Zealanders, each with their own medical and nursing staff. The bed complement was soon increased to 562, then 650. For those patients who could take advantage of them, instructional workshops and commercial classes were set up, as well as a poultry farm. Many also took lessons in foreign languages. Under the direction of Sir Harold Gillies, the hospital acquired a worldwide reputation for plastic surgery. By 1920, as the number of patients with maxillofacial injuries had fallen, general medical cases began to be admitted, and the hospital passed to the control to the Ministry of Pensions. It closed in 1929. The hospital buildings were sold to the LCC in 1930. It reopened as Queen Mary's Hospital, a general hospital. During the Second World War, it was damaged by bombs but continued to function. In 1948, it joined the NHS with some 300 beds in hutted wards. During the 1960s, the hospital was completely rebuilt on an adjacent site, completed in 1974 with 644 beds. Its A&E Department closed in 2010.

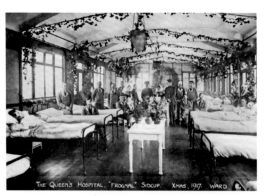

THE QUEEN'S HOSPITAL, "FROGNAL" SIDCUP.   XMAS, 1917.   WARD 8.

Fig. 108: A ward decorated for Christmas 1917.

*The hospital is still operational. The Grade II\* listed Georgian mansion Frognal House became a residential and nursing home in 1999. Heathland and woodland have reclaimed the site of the original hutted hospital.*

By the turn of the twentieth century, the smallpox hospital ships *Atlas*, *Endymion* and *Castalia*, were in poor condition, expensive to maintain and limited in how many patients they could hold. The Metropolitan Asylums Board decided to replace them with a new, large smallpox hospital on the 315 acres of land of the Joyce Green estate it owned at Long Reach. Building work started on Joyce Green Hospital in 1901, just as another smallpox epidemic began. Temporary hospitals – Long Reach Hospital and Orchard Hospital – were hurriedly erected early in 1902 to the north of the new hospital.

**Long Reach Hospital** opened in February 1902 on the banks of the Thames immediately to the east of the Long Reach pier buildings, where the River Ambulance Service ferried patients, staff and visitors to and from London. It had 300 beds in a long row of single-storey huts made from wood and iron. In 1910, as smallpox had declined, the service was reorganised. Long Reach Hospital was reserved for smallpox cases, while its sister hospitals were used for convalescent patients or those with other infectious diseases. Originally built with a two-year life expectancy, the hospital desperately needed repairs, but the outbreak of the First World War delayed the work. The huts were eventually replaced in 1929 by seven

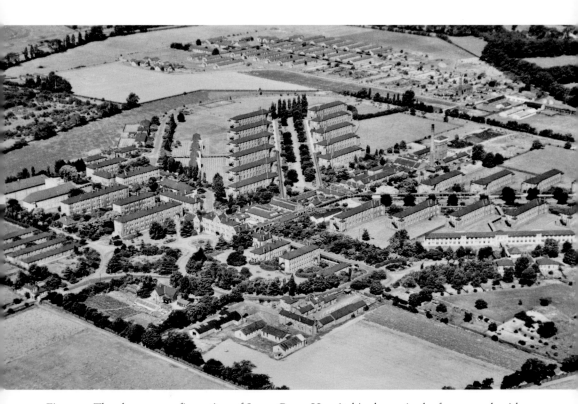

Fig. 109: The chevron configuration of Joyce Green Hospital is shown in the foreground, with the smaller Orchard Hospital beyond. Long Reach Hospital and the river are out of sight beyond the top right corner of the image.

permanent ward blocks. The hospital then had 250 beds. It was completed just in time for an outbreak of *variola minor*, a milder form of smallpox (London's final smallpox epidemic). The River Ambulance Service ceased in 1930, when the LCC took over control (land ambulances being favoured by the new regime). Long Reach pier was demolished in 1936.

In 1948, the River Hospitals joined the NHS. During the Great Storm of 1953, the Thames flooded and the hospital was submerged to a depth of 2 metres. The gate porter, the only member of staff on duty, waded to Joyce Green Hospital, about 1 km away, where floodwaters had reached its north gate. During the 1960s, fifty beds were kept on stand-by and could be opened within two hours of notification. Staff were on permanent stand-by, receiving a small stipend. They worked a 14-hour shift, being revaccinated whenever a smallpox patient was admitted (staff to patient ratio was 14:1). Their clothing was destroyed at the end of each shift. By 1973, only thirty beds were kept on stand-by. In March of that year, a smallpox patient was admitted, the last to be treated at the hospital, which closed in 1974. Arrangements were made for the Cray Valley Hospital (*see p. 91*) to deal temporarily with future smallpox cases.

*The buildings were demolished to make way for improved flood defences.*

**Orchard Hospital.** The second River Hospital opened just south of Long Reach Hospital in the spring of 1902. It had 800 beds. By this time, the smallpox epidemic was already subsiding and, in 1910, it became a fever hospital, spending much of its time closed, opened only for epidemics, mainly of scarlet fever and diphtheria.

It was empty at the outbreak of the First World War but, in 1915, it became the Orchard Military Hospital, then in October 1916 the 3rd Australian Auxiliary Hospital. The Australians greatly improved the site, even adding an operating theatre. After the war the hospital closed, opening occasionally for epidemics. In 1939, at the outbreak of the Second World War, it received chronically sick patients temporarily evacuated from the Midlands. The wooden huts were highly vulnerable to incendiary bombs and, in 1940, the east buildings were destroyed.

*The damaged buildings were demolished and the remaining ones used as a pig farm by Joyce Green Hospital, until they too were demolished.*

Fig. 110: Long Reach – the foreshore by the location of the hospital (the buildings were demolished to make way for improved flood defences). The Queen Elizabeth Bridge can be seen in the distance.

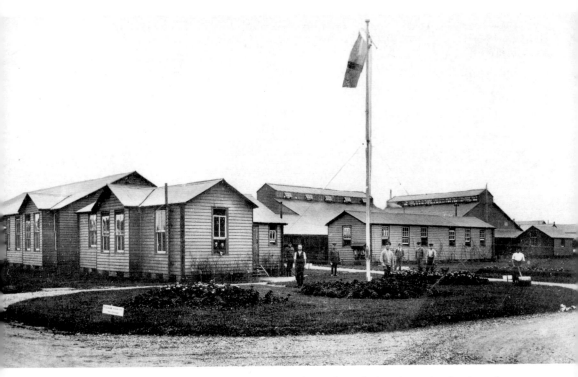

Fig. 111: Orchard Hospital, made of iron and wood, was furnished with surplus furniture from the nearby Gore Farm Hospital.  Gas lighting was used in all the wards.

**Joyce Green Hospital** opened in December 1903 with 940 beds, just as the smallpox epidemic had ended. It consisted of twenty-two two-storey pavilions of forty beds each, including isolation wards for sixty patients. Between them, the three River Hospitals had just over 2,000 smallpox beds; Gore Farm (Southern) Hospital (*see p. 99*), used for recovering patients, had an additional 1,000 beds. The old hospital ships were disposed of shortly afterwards, but the pier-side buildings were retained as an additional self-contained hospital of fifty beds for sporadic cases of smallpox.

In 1910, it became a fever hospital for cases of scarlet fever and diphtheria (and, later, measles and whooping cough). In 1919, the 254 acres of its grounds were planted with many shrubs and trees and it became a centre of plant propagation, supplying the other institutions belonging to the Metropolitan Asylums Board. In 1922, there was a minor epidemic of smallpox in which 107 patients died. After that, the hospital was more or less empty, but it survived the threat of demolition and was instead repaired and rebuilt, with new isolation units. In 1926, electric lighting was installed. In 1928, there was an epidemic of *variola minor*, a milder type of smallpox. In 1930, the LCC took over control of the River Hospitals. Joyce Green Hospital lay empty and was never used for smallpox again. During the Second World War, it became a general hospital as part of the EMS, with the number of beds increased from 986 to 1,900. During 1944, part of the site became the Netherlands Military Hospital. Only minor damage to the hospital buildings occurred during the war. When the Thames burst its banks in 1953, an adjacent fireworks factory was flooded, causing a chemical reaction resulting in a fire and three explosions; five hundred panes of glass were broken at the hospital.

In 1953, it became a centre for the treatment of poliomyelitis. It had 341 beds, including those at the Orchard Hospital. The wards were modernised in 1959 to receive patients and staff from the Southern Hospital, which closed. A new twin operating theatre opened in 1963. A Cervical Cytology Unit was established in 1966, as well as a 'Well Woman' Clinic, the first in the country. A Psychiatry Unit with fifty-four beds for short-term patients was established in 1969. In 1970, a new unit for mentally handicapped patients opened (this later became Orchard House) and work began on a £60,000 paediatric block. By 1985, the hospital had 515 beds. In 1991, in an arson attack, the laundry building was burned down. Over £2 million of damage was caused and half the linen supplies lost. A Day Care Unit for minor surgery opened in 1992 and, in 1996, an A&E Department. By 2000, the hospital had 363 general beds and fifty-five psychiatric beds. It closed in September when the newly built Darent Valley Hospital opened.

*The hospital has been totally demolished. The area is being comprehensively redeveloped, mainly as housing.*

# Southern Hospital
## Gore Road, Dartford, Kent

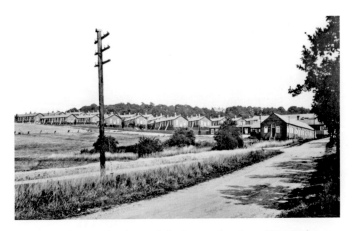

Fig. 112: The wooden huts of the Lower Southern Hospital.

In 1883, the Metropolitan Asylums Board purchased the 160-acre Gore Farm to build a hospital for recovering smallpox patients discharged from the hospital ships at Long Reach. Gore Farm Hospital opened in 1884 during an epidemic. It consisted of fifteen double tents (one tent inside another for weather protection). In 1887, eight temporary huts (each with twenty-six beds) were built on the southern part of the farm and named the Lower Hospital. In 1890, permanent buildings were erected on higher ground and became the Upper Hospital with 1,000 beds. During the next smallpox epidemic, the Upper Hospital was full of scarlet fever patients, so the Lower was extended to 850 beds. When Joyce Green Hospital (*see p. 98*) opened, Gore Farm became a convalescent home for fever and general patients. Renamed the Southern Convalescent Hospital in 1908, it was simply the Southern Hospital by 1911. During the First World War, the Lower Hospital became the Dartford War Hospital with 1,200 beds for wounded German soldiers. In 1918, the Upper Hospital became the United States Base Hospital No. 37, the largest American military hospital in England with 2,000 beds (some in wooden huts). When the Armistice was announced, the Germans and Americans celebrated together. After the war it again became a fever and convalescent hospital. By 1924, the Upper Hospital had 600 beds and the Lower 160. In 1930, the LCC took it over. At the outbreak of the Second World War, it joined the EMS. Its facilities were upgraded and it became one of the largest general hospitals in England, with 1,580 beds. After the Second World War, most of the wooden huts were demolished (the surviving ones for a time became the Mabledon Hospital).

In 1948, it joined the NHS as a general hospital until closing in 1959, deemed too big and unsuitable for modernisation. Patients and staff were transferred to Joyce Green Hospital.

*In 1967, the buildings were demolished. The Dartford bypass (the A2) was built through the site. The remainder of the land is now part of Darenth Country Park.*

# St Olave's Hospital
## Lower Road, Rotherhithe, SE16 2TU

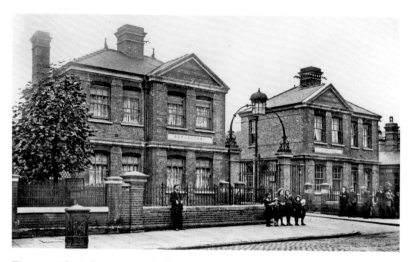

Fig. 113: The infirmary was built adjacent to St Olave's workhouse.

The Rotherhithe and Bermondsey Infirmary opened in 1875 with 175 beds. In 1877, it was enlarged. The workhouse moved away in 1884 but the infirmary remained, and was extended again during 1890–92. In 1930, it came under the control of the LCC, who renamed it St Olave's Hospital. Operating theatres were installed and it became a general hospital with 687 beds. During the Blitz in the Second World War, the maternity block was severely damaged by a high explosive bomb. Further bomb damage occurred in 1941. In August 1944, a V1 flying bomb damaged a third of the buildings and, in November, a V2 rocket fell in the courtyard, causing severe damage; amazingly no one was killed. In 1945, another V2 exploded by the nurses' home.

In 1948, it joined the NHS, with 515 beds, of which only 350 were staffed. By 1954, it had 315 beds. A campaign was launched to recruit foreign nurses, resulting in the employment of a veritable United Nations – some fourteen nationalities. By 1957, only three of the twelve wards had been modernised, while the Outpatients Department was housed in a large temporary building. By 1961, it had 496 beds. In the late 1960s, it became the first general hospital to open its doors to psychiatric patients. In 1979, despite improvement to the facilities, the District Health Authority decided to 'temporarily' close it to save money. A new day centre for psychogeriatric patients, constructed at a cost of £40,000, remained unused. Services were run down and the hospital finally closed in 1985 with 220 beds.

*Only the gatehouse survives. The site was redeveloped in the 1990s as a housing estate around Ann Moss Way. The Outpatients Department was converted into St Olave's House Nursing Home, which closed in 2008; the building is now derelict (2014).*

# Chapter 8

# South-West Metropolitan Region

As well as south-west London, this region covered much of Surrey and parts of Dorset and the Isle of Wight. It contained many asylums for the County of London, including the 'Epsom cluster' (*see p. 115*), Belmont and Henderson Hospitals (Sutton), St Lawrence (Caterham), Springfield (London) and Warlingham Park.

One of the few hospitals for women run by women was located in this region. The South London Hospital for Women and Children was founded in 1913 by two surgeons who had trained at the New Hospital for Women (*see p. 41*), which was overwhelmed by work.

By the end of the twentieth century, only a quarter of the hospitals remained.

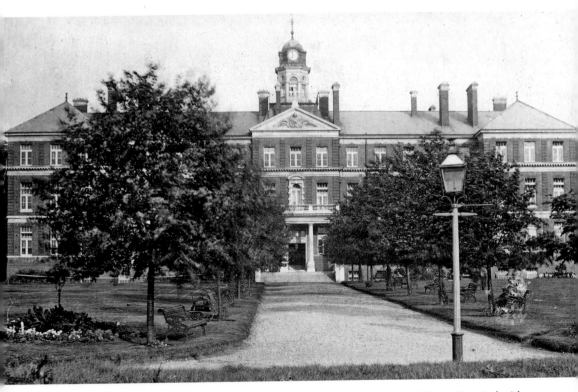

Fig. 114: The Tooting Home for the Aged and Infirm became the Tooting Military Hospital with 710 beds during the First World War. After the war it remained empty until bought by the LCC in 1930 and reopened in 1931 as St Benedict's Hospital for convalescents or the chronically sick. It joined the NHS and finally closed in 1981. The only surviving remnants of the hospital buildings are the entrance gateway with its posts on Church Lane, and the main block's portico and clock tower, which have been preserved in the grounds of the modern housing development.

# Atkinson Morley's Hospital
## Copse Hill, Wimbledon, SW20 0NE

Fig. 115: The hospital building in 2008, five years after it had closed. Built during 1867–69 it was the first purpose-built facility to be associated with an inner city hospital.

Atkinson Morley, a former medical student, was the proprietor of the Burlington Hotel and one of the Governors of St George's Hospital (*see p. 35*). He died in 1858, leaving the hospital £150,000 to build its own convalescent home in a quiet place (he had been disturbed by traffic noise while recovering from an operation at the hospital). Land in Wimbledon was purchased and Atkinson Morley's Convalescent Home opened in 1869. A large laundry was also built on the site, and patients and laundry from the hospital were transported to Wimbledon in two-horse closed carriages on Wednesday afternoons. In 1888, the carriages were replaced by an omnibus, which could carry fourteen people. In 1901, the ceiling of the children's ward collapsed. No one was injured but the other ceilings were found to be in a precarious state. The home closed for repairs, during which time electricity was installed. Gradually acute cases and TB patients were also admitted. During the Second World War, it was upgraded to 120 acute beds. In 1942, the surgical wards were taken over for neurosurgery and it became Atkinson Morley's Emergency Hospital.

It joined the NHS in 1948 as an internationally recognised neuroscience centre with 124 beds. Departments in Psychiatry and Neuroradiology were established in 1949. In 1971, it was the first NHS hospital to acquire a clinical CT scanner. A sleep laboratory opened in 1972. By 2000, the hospital was considered outdated and it closed in 2003; services transferred to the new Atkinson Morley Wing on the St George's Hospital campus at Tooting.

*The 23-acre site was sold in 2006. Building work began in 2013 for a new housing estate – Wimbledon Hill Park. The dilapidated hospital building will be converted into luxury apartments.*

# Banstead Residential Open Air School
## (Surgical Home for Boys)
### Park Road, Banstead, Surrey, SM7 3DL

Fig. 116: The Banstead Convalescent and Surgical Home for Boys with Open Wounds opened in 1896 with twenty beds.

Located in a large house that had been built in 1894 for use as a residence or institution, the home was intended for boys with a temporary physical disability, due to operation or illness, unable to attend normal schools. By 1899, it had twenty-five beds. Most patients had been sent from London hospitals. Many had pre-tuberculosis and the fine, pure, dry air of Banstead proved beneficial to them. By the late 1930s, the home had thirty beds, all in one large ward on the ground floor. It was renamed the Banstead Residential Open Air School, for boys aged from five to eleven years. During the Second World War, they were evacuated to Reigate.

The home did not join the NHS in 1948 but came under the control of the Ministry of Education as a voluntary institution. The children stayed about eighty-seven days, but this increased progressively. By 1956 it was one year, although most went home for the school holidays (the others remained at the school). The children suffered from physical illness, such as debility, bronchiectasis, asthma and enuresis, or were recovering from polio. Some had been admitted for social reasons, for example, being from broken homes. All had been referred by local education authorities from around the country. By 1957, such homes for delicate children were being replaced by special schools. The home closed at the end of 1961.

*In 1962, the premises became the Edith Edwards House School, a residential home run by the Invalid Children's Aid Association for twenty-one autistic and highly disturbed children. It closed in 1984, and the property was then taken over and extended, reopening in the same year as the Parkside Nursing Home.*

# Bolingbroke Hospital
## Wakehurst Road, Wandsworth Common, SW11 6HN

Fig. 117: Bolingbroke House around 1900 before the hospital was extended. It was demolished in 1937.

Canon J. Erskine Clarke, vicar of St Mary's church, Battersea, drove the establishment of a voluntary hospital in the area. In 1876, an old mansion, Bolingbroke House, was purchased from Viscount Bolingbroke for this purpose. It opened in 1880 as a small general hospital (one of the earliest for middle-class patients) with a Casualty Department. In 1901, the Victoria Memorial Wing was built for the Outpatients Department. The Canon Erskine Clarke Wing opened in 1906, and the Bolingbroke Wing in 1914. The hospital was again extended in 1927 to 115 beds. Bolingbroke House was demolished in 1937. At the outbreak of the Second World War, when it had 135 beds, the hospital joined the EMS, affiliated with St Thomas' Hospital. It was damaged by bombs in 1941 and hit by a V1 flying bomb in 1944.

Despite misgivings from the Hospital Board, it joined the NHS in 1948. The A&E Department closed in 1974, despite local protests. During the 1980s, the hospital began to focus on services for older people, but the buildings were deteriorating and the issue of fire safety was raised (the elderly patients were housed on the upper floors). No action was taken but, after an independent fire safety report in 2004, the remaining fifty-four beds closed in 2005 (despite more than £2.5 million having been spent on refurbishing the wards). It became a community hospital, but the NHS felt the buildings were run-down and underused, being 80 per cent empty. There was immense opposition from the local community to the proposed closure and Wandsworth councillors managed to block the plan. The issue was referred to the Secretary of State for Health, who agreed to its closure in 2007.

*In 2009, the red-brick buildings were Grade II listed. Wandsworth Council acquired the site from St George's Hospital Trust in 2011. It is now the Bolingbroke Academy, a secondary school that opened in September 2012.*

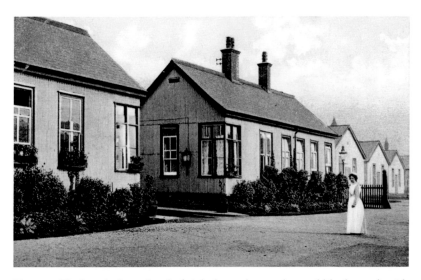

Fig. 118: The hospital consisted of eight bungalow-style ward blocks, each with twenty-four beds, a bathroom, scullery, linen room, a nurse's bedroom and WC.

In 1893, during a resurgence of scarlet fever, the Metropolitan Asylums Board opened the Fountain Fever Hospital as an annexe to the adjacent Grove Fever Hospital. Temporary wooden huts, arranged in pairs, were built in nine weeks; their exteriors were covered in boarding, felt and corrugated iron, and their interiors lined with boarding and asbestos on plaster. Later, in 1912, it became the Fountain Mental Hospital, for 'unimprovable imbeciles' (the lowest grade of severely disabled children), many of whom were helpless, paralysed or epileptic. By then it had sixteen bungalows, each with forty beds. By 1913, there were 666 beds in nineteen blocks. A school started in 1917 for those who could attend (about 200 patients), with singing, dancing and drill classes. Children not confined to bed spent the maximum time outdoors; in fine weather, all meals were served outdoors to maximise exposure to fresh air and sunlight. In 1930, control passed to the LCC. In 1944, three wards were totally destroyed and the rest severely damaged by a flying bomb. The children were evacuated.

In 1948, it joined the NHS as the Fountain Hospital, with 630 beds. The old huts, originally intended to last ten years, were almost fifty-five years old. By 1958, the hospital, with 600 children, was immensely overcrowded; it was difficult to move between the beds. The Ministry of Health decided to use the site for the new St George's Hospital and the patients were gradually transferred to Queen Mary's Hospital in Carshalton (*see p. 16*). The hospital closed in March 1963.

*The hospital was demolished in 1963. Its site is now occupied by St George's Hospital.*

# Nelson Hospital
## Kingston Road, Merton, SW20 8DB

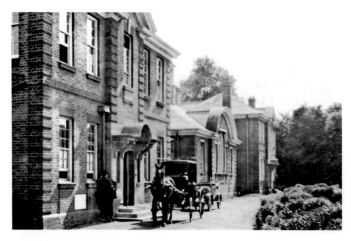

Fig. 119: The hospital consisted of three pavilion blocks – the central one-storey buil flanked by a two-storey ones on either side.

With the arrival of the railway, the population in South Wimbledon had greatly increased. The South Wimbledon, Merton and District Cottage Hospital in Merton Road, opened in 1900, had become too small. In 1905, the centenary of Admiral Nelson's final victory at Trafalgar, a fund was organised for a new hospital, which opened in 1912. The Nelson Hospital had twenty-eight beds in eight wards named after famous ships, battles and men, such as *Trafalgar*, *Copenhagen*, *Victory*, *Vanguard*, *Hardy* and *Collingwood*. In 1918, the hospital was asked by the newly formed Ministry of Pensions to install an X-ray Department and to provide massage and electrical treatments for local ex-servicemen needing continued care. A new wing was added in 1922 to commemorate Merton soldiers killed during the First World War. In 1924, an adjacent site was purchased for a new Maternity Wing, which opened in 1931 with twenty-one beds. At the same time, an upper floor was added to the central block. The hospital then had eighty-six beds. An Outpatients and Casualty Department opened in 1932. After the Second World War, building work commenced in 1947 to extend the Maternity Wing to forty-seven beds.

The hospital joined the NHS in 1948 with 116 beds. Over the years, the buildings were extended and modified. By 1966, there were 128 beds. In 1980, the Maternity Wing was converted into a sixty-bed surgical unit with a new operating theatre, while three wards in the main building became a forty-eight-bed geriatric unit and day hospital for the elderly. The hospital closed in 2013.

*The site is being redeveloped into the Nelson Local Care Centre, due to be completed in 2015. The façades of three of the original pavilions will be 'sensitively' incorporated into this; the other buildings have been demolished. An assisted living home is being built on the former car park.*

# Purley War Memorial Hospital
## 856 Brighton Road, Purley, Surrey, CR8 2YL

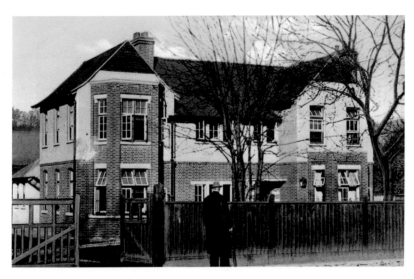

Fig. 120: The hospital, although it served Purley and Coulsdon, was not actually in Surrey when it was built, but just within the point of a V-shaped salient of the County Borough of Croydon; it had been the only available site.

The Purley and District Cottage Hospital opened in 1909 with seven beds. After the First World War, in 1919, a large surplus army hut was erected in its grounds as a Red Cross Curative Post for discharged servicemen with damaged limbs (it closed in 1926). In return for allowing this, the hospital was allocated two-fifths of the hut, which it used as offices and a ward. In 1921, two new ward blocks were added and it was renamed the Purley and District War Memorial Hospital. Plans were made to extend the hospital in 1938 to provide extra beds, a maternity home, an Outpatients Department, a new kitchen and boiler room. Work began on the first phase and the new kitchen was completed in 1939, just at the outbreak of the Second World War. The boiler house and the Outpatients Department were completed in 1940, so that the latter could be used as a First Aid Post. During the Second World War, the hospital became part of the EMS with fifty-one beds.

The hospital joined the NHS in 1948 as a GP hospital. By 1962, it had fifty-five beds. The Outpatients Department had a Casualty Department, and X-ray and Physiotherapy Departments, but no clinic rooms (outpatients were those referred by their GPs for X-ray or physiotherapy). In 1984, it became a geriatric hospital with fifty-seven beds, but still operated an Outpatients Department. The Casualty Department closed in 1989. The wards closed in 1999 when the Jubilee Wing of the Mayday Hospital opened.

*After much delay, a £11.5 million makeover of the outpatients building into an urgent care centre was completed in July 2013. The original 1909 building provides the entrance to the current outpatients facilities.*

Fig. 121: Roehampton House, the original hospital building, is now an apartment block.

The Queen Mary Convalescent Auxiliary Hospital opened in 1915 for the rehabilitation of servicemen who had lost limbs during the First World War. It occupied Roehampton House, a stately home that had been requisitioned by the War Office. Originally intended to have only 200 beds, it expanded rapidly as casualties increased (by 1917 some 100 new patients were arriving weekly). By the end of the war, it had 900 beds and had gained an international reputation as a pioneering limb-fitting and rehabilitation centre. In 1920, the hospital governors bought Roehampton House and established factories and workshops for making prosthetic limbs. By 1922, civilian amputees were also admitted. In 1925, it was renamed Queen Mary's (Roehampton) Hospital. At the outbreak of the Second World War, when it had 700 beds, it came under the control of the Ministry of Pensions. The Limb Fitting Centre was expanded, but better medical and surgical techniques had reduced unavoidable amputations to about half those of the First World War.

The hospital continued to be run by the Ministry of Pensions until 1961, when it joined the NHS as Queen Mary's University Hospital. In 1957, a villa was converted into a mental health centre. In 1983, Roehampton House had to be vacated while asbestos was removed; it reopened in 1987. The Douglas Bader Centre opened in 1993, financed by the Douglas Bader Foundation. By the early 1990s, the hospital had 450 acute beds, but services began to be run down. In 1997, the A&E Department closed. It was decided that, as most patients were elderly, an acute hospital was no longer necessary. The mental health centre was demolished in 2000, and construction began on its site for a community hospital. The new £55 million hospital opened in 2006 with 130 beds.

*Roehampton House has been converted into luxury apartments. Its two gatehouses and the remainder of the Roehampton estate were redeveloped as a luxury housing estate – Queen Mary's Place.*

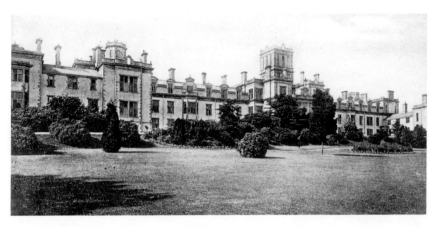

Fig. 122: The main building had a five-storey central tower some 27 metres high, with a two-storey entrance in front. On either side were three-storey wings.

In 1847, Mrs Ann Serena Plumbe, dismayed at the difficulties faced by her mentally handicapped son and other such children, wrote over 600 letters to individuals who might help establish an institution for their training and education. The philanthropist Revd Dr Andrew Reed agreed on condition she find six idiot children within six days. She found twenty-eight, most living in a wretched state and, in 1848, Park House in Highgate opened as a 'hospital for idiots', the first of its kind in England. For a more permanent solution, a 155-acre site at Earlswood Common was acquired, and the National Asylum for Idiots opened in 1855 with 405 beds. Patients were educated as far as possible and the able-bodied taught a trade; they also worked on the farm and in the kitchen, wards and laundry. Music was encouraged. After extension, the asylum had 600 inmates by 1878, half aged under twenty years. In 1902, it was renamed the National Training Home for the Feeble-Minded. In 1904, the buildings, erected on Wealden clay but with practically no foundations, began to subside and immediate action had to be taken for the safety of the inmates. In 1914, when it had 490 inmates, it was renamed the Royal Earlswood Institution for Mental Defectives.

In 1948, it joined the NHS with 678 beds, becoming Royal Earlswood Hospital in 1959. During the 1970s, patients were gradually transferred to rehabilitation units to learn the necessary skills in self-sufficiency, such as how to handle money, shop, cook and use public transport. In 1990, when it had 479 beds, a gradual closure programme began and it closed in 1997. The remaining 120 residents were rehoused 'in the community'.

*The Grade II listed main building has been restored and converted into private apartments – Victoria Court. Other buildings were converted into 120 dwellings and the former hospital is now a gated community. Some 180 new homes have been built in the grounds.*

# St Helier Hospital
## Wrythe Lane, Carshalton, Surrey, SM5 1AA

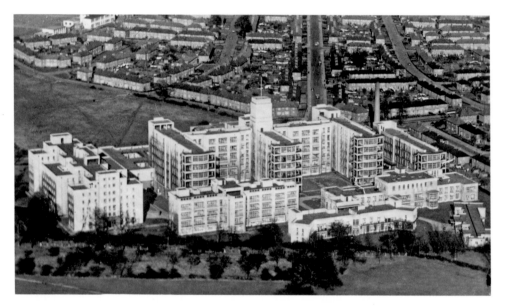

Fig. 123: An aerial view showing the extent of the hospital buildings.

Between 1928 and 1936, the LCC built the St Helier Estate to rehouse people living in overcrowded conditions in inner London. It was the largest built by the council south of the Thames, and was named after Lady St Helier, a former alderman. In the late 1930s, Surrey County Council built St Helier Hospital, which opened in February 1941 with 862 beds. It had been completed by 1940 but, because of the war, could not be properly equipped or staffed. Its six buildings were painted dark grey to make them less visible to German bombers but, less than a month after it had opened, it was severely damaged by a landmine. The maternity and children's wings were destroyed and the few inpatients were evacuated. Admissions resumed in May 1941. In 1944, a flying bomb destroyed the residence of the medical superintendent, who lost an eye. After the war, the hospital was gradually brought into full use (a process that continued until 1955).

In 1948, it joined the NHS, but suffered from a shortage of nursing staff; recruitment was difficult as the site was poorly served by public transport. In 1952, it had 763 beds. During the 1960s, it was found that the concrete foundations were deteriorating – Epsom salts (magnesium sulphate) in the ground had created a chemical reaction that destroyed concrete. By 1966, the roofs and drainage systems were also causing trouble. In 1969, a Renal Unit was established. In 1975, the hospital was modernised and re-equipped. An A&E Department opened in 1977 and, in 1987, a new £2 million maternity unit.

*In March 2010, a plan was approved to redevelop the site and replace some of the buildings, but the project has stalled.*

# St Stephen's Hospital
## Fulham Road, Chelsea, SW10 9TH

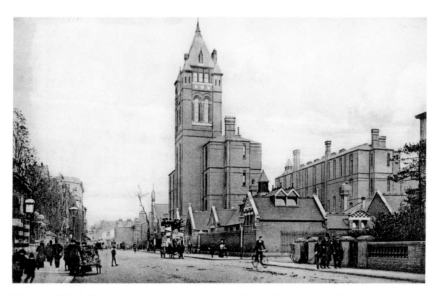

Fig. 124: The infirmary was the largest in London when it was built in the 1870s.

In 1876, St George's Union purchased a piece of land adjacent to its workhouse in Fulham Road to enable the workhouse to be extended and a separate infirmary with 800 beds to be built alongside. The infirmary opened in 1878, and consisted of seven pavilions linked by a single-storey corridor. Each floor of the four-storey pavilions contained a twenty-eight-bed ward. In 1915, it became known as the Fulham Road Infirmary. In 1924, it was renamed the City of Westminster Hospital. In 1931, when it had 796 beds, the LCC took it over and renamed it St Stephen's Hospital. During the Second World War, two ward blocks were damaged by bombs.

In 1948, the hospital joined the NHS with 450 beds. New operating theatres were built in 1952, on the site of one of the war-damaged blocks. The small Outpatients Department and the Physiotherapy and Occupational Therapy Departments were extended. By 1953, there were 501 beds, in some wards set close together. There was little privacy on the wards and the sanitary annexes were primitive, with two WCs and one bath (for twenty-eight patients) and an open sink with a jet for washing bedpans. The Pathology Laboratory was located in part of the workhouse buildings, but the X-ray Department was modern and adequate. A new three-storey Outpatients Department opened in 1965. Later, in 1971, a new ward block was added. The hospital closed in 1989 and was demolished. The only part to survive is the adjoining Kobler Centre (later renamed St Stephen's Centre), which opened a year before the hospital closed.

*The new Chelsea and Westminster Hospital, with 580 beds, was built on the site and opened in 1993.*

# Wandle Valley Hospital
## Mitcham Junction, Surrey, CR4 4XL

Fig. 125: The hospital suffered from a surfeit of addresses – variously noted as Beddington Corner, Wallington, Mitcham or Carshalton, or Mitcham Junction, Surrey. They all describe the same location.

As the residents of Carshalton had objected to an infectious diseases hospital near their village, it was built instead in the Wandle Valley. The Wandle Valley Isolation Hospital opened in 1899, with twenty-eight beds for patients with scarlet fever, typhoid and diphtheria. In 1904, a new ward with twenty-two beds opened. In 1910, a twelve-bed block was added and another with sixteen beds in 1921. In 1932, two new wards for sixty patients opened. In 1938, another two wards with sixty beds were added, but three were condemned, losing thirty-eight beds. During the Second World War, wards were closed due to a lack of staff.

In 1948, the hospital joined the NHS with 152 beds. The wards gradually reopened and were modernised, but the remote location made staff recruitment difficult during a national shortage of nurses. In 1953, it had 140 beds (eighty for infectious disease cases and sixty for the elderly chronically sick). With the advent of antibiotics, there was little need for isolation wards and they gradually filled with geriatric patients. In 1957, there were seventy-two beds for the chronic sick and fifty for isolation cases; the remainder were unstaffed. In 1974, the hospital had 160 beds for orthopaedic, fever and geriatric patients. By 1984, it had become a geriatric hospital with ninety-five beds. It closed suddenly in January 1987 as an 'emergency measure' to save money, its remaining seventy elderly patients being transferred to other accommodation, despite freezing winter temperatures.

*The hospital was demolished in the late 1980s. Its site is now occupied by a pleasant housing estate with a large green beside the River Wandle. Part of its grounds form the Wandle Valley Wetland, a local nature reserve.*

# Chapter 9

# Hospitals for the Mentally Ill

From the mid-nineteenth century, the counties began to build asylums for mentally ill paupers accommodated in workhouses. These asylums were isolated self-sufficient communities; each had its own blacksmith, tinsmith, cobbler, tailor, upholsterer, bakery, laundry, gasworks, water supply and chapel. Asylum farms provided fresh produce and manual labour for the patients; those incapable of learning a skill cleaned the wards and corridors. For leisure time, exercise and sports were encouraged. Indoor entertainment included weekly dances, and card and board games.

In 1889, the new London County Council (LCC) inherited four asylums from the counties of Middlesex and Surrey, but soon erected two more, as the need for beds was intense. By 1924, seven more had been built, while a special hospital (the Maudsley Hospital) had opened in 1923 for voluntary mental patients (i.e. they had not been sectioned, or compulsorily admitted). The Mental Treatment Act 1930 enabled public mental hospitals to receive voluntary patients for the first time (it also expunged the term 'asylum' from official use). In 1955, the Ministry of Health decided that hospital farms should close, as patients should not be used to maintain their institutions, a development that heralded the breakdown of these insular worlds.

Following the Mental Health Act of 1959, the word 'mental' was omitted from hospital names, to emphasise that all patients were on an equal footing. New psychotropic drugs introduced in the 1960s enabled patients to be treated at home, while changes in social attitudes towards the mentally ill led to questioning the need for large asylums. During the 1970s, psychiatric departments began to be established in general hospitals and the asylums slowly emptied. The Community Care Act 1990 accelerated this process. The redundant asylums were sold for redevelopment.

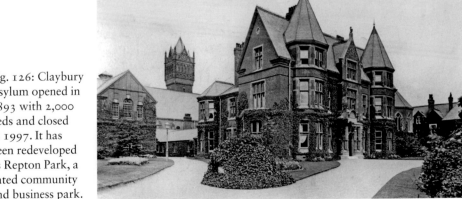

Fig. 126: Claybury Asylum opened in 1893 with 2,000 beds and closed in 1997. It has been redeveloped as Repton Park, a gated community and business park.

# Cane Hill Hospital
## Portnalls Road, Coulsdon, Surrey, CR3 3YL

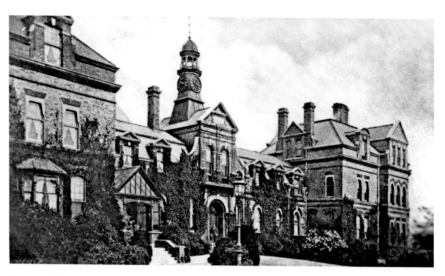

Fig. 127: The main entrance. The asylum was built to high standards.

The Third Surrey County Pauper Lunatic Asylum opened in December 1883, the largest of its type in the United Kingdom, with accommodation for 1,124 patients – 644 women in the west wards and 480 men in the east. Its 180-acre farm provided milk, eggs, fresh meat and vegetables, while the kitchens and bakeries fed patients and staff – almost 2,000 people. Male patients worked on the farm, in the gardens and the workshops, and the females in the kitchens, wards and laundry. Recreational activities included outdoor sports, while dances, concerts and theatrical performances were held in the main hall (where the sexes could mix). In 1889, the LCC took over control and extended it to 2,000 beds. In 1930, it was renamed Cane Hill Mental Hospital, but it remained unmodernised (electric lighting was not installed until much later) and overcrowded. By 1937, it housed 890 male and 1,355 female patients; each ward, designed to accommodate seventy, contained eighty or ninety. During the Second World War, six wards were taken over by the EMS, while 300 patients were transferred from Horton Hospital (*see p. 116*), increasing the number to 2,500.

It joined the NHS in 1948 with 2,264 beds. In 1959, it was renamed Cane Hill Hospital. The farm closed during the 1960s. Talking therapies and new drugs reduced the need for hospitalisation; from 2,240 beds in 1965, there were 1,625 by 1974. 'Care in the Community' led to patients being found alternative accommodation in smaller groups. By 1983, the hospital had 900 beds and 787 by 1988. It closed in March 1991.

*The buildings were left empty and began to deteriorate. Apart from the chapel and the water tower, they have now been demolished and the site is being redeveloped to provide new homes and businesses.*

In 1896, the LCC purchased the 1,000-acre Horton Manor estate near Epsom, which included five farms, at the cost of £35,900. It intended to build six institutions, each to accommodate 2,000 patients. In the event, only five were built but, nonetheless, the estate held the largest cluster of mental asylums in the world. The first to open in 1899 was the Manor Asylum. The second, in 1902, was the Horton Asylum. The third, in 1903, was the Ewell Epileptic Colony, later renamed St Ebba's Hospital. Long Grove Asylum opened in 1907 and West Park Asylum, delayed by the First World War, in 1921. By 1960, the Epsom cluster had 7,000 beds, 1,524 of which were at Horton Hospital. The farmlands of the cluster, sold in 1973, now make up the 400-acre Horton Country Park, with Horton Park Children's Farm, a petting zoo, on Horton Lane.

## Manor Hospital
### Horton Lane, Epsom, Surrey, KT19 8NL

Building work commenced on the Horton Asylum, but a temporary one was built around the Horton Manor House to relieve overcrowding in other asylums. It opened in 1899 as the Manor Asylum, with the manor house as offices, while the patients (700 harmless chronic female patients) were housed in huts made from wood and corrugated iron. A farm provided work for them (and produce for the asylum). In 1901, huts were added for 100 male patients. By 1909, ten permanent brick buildings had been built. During the First World War, the patients were evacuated in 1916 and the asylum became the Manor (County of London) War Hospital with 1,170 beds, of which 500 were for malaria cases. In 1922, malaria therapy was used to treat patients with general paralysis of the insane, caused by syphilis of the central nervous system. Syphilis, a bacterial infection, sometimes responded to recurrent fevers, so deliberate infection with malaria could improve a patient's condition. When West Park Hospital opened in 1921, Manor Hospital became a Certified Institution for Mental Defectives. The new patients continued to provide labour.

It joined the NHS in 1948 with 1,292 beds, caring for moderately mentally handicapped young adults and disturbed adolescents, and gained an international reputation in the field of industrial and behaviour therapy. In 1951, it had 1,417 beds, reduced to 1,200 by 1960. By 1971, the state of the temporary huts was causing concern – built with a life expectancy of fifteen years, they were still in use seventy years later. They were demolished and replaced by large red-brick bungalows. In 1979, the hospital had 800 beds but, as patients were gradually integrated into the community, it gradually emptied. In 1985, it had 621 beds, but by 1990 only 454. The thriving market garden run by the patients became more difficult to maintain. The hospital finally closed in 1996.

*A few buildings survive as residences, but the rest have been demolished. The site is now Manor Park, a housing estate.*

# Horton Hospital
## Long Grove Road, Epsom, Surrey, KT19 8PZ

Fig. 129: Former ward blocks have been converted into residences.

Horton Asylum opened in 1902 with 2,000 beds. During the First World War, its 2,143 inmates were transferred, and from 1915 to 1919 it became the Horton (County of London) War Hospital, for wounded servicemen from all parts of the Empire. After the war it was renamed Horton Mental Hospital, mainly for women (in 1922, only 187 of its 1,605 patients were men). In 1925, the Malaria Therapy Unit transferred from Manor Hospital to its isolation block. During the Second World War, the malaria research proved invaluable for developing anti-malaria drugs for troops in the jungles of the Far East. At the outbreak of the Second World War, the patients were again transferred and it became the Horton Emergency Hospital, a general EMS hospital with 2,178 beds (2,330 by 1944). After the war, the buildings and grounds were in a grievous state. Mental patients began to return in 1947, but many wards remained closed due to lack of nurses.

In 1948, it joined the NHS with only 527 beds open and few trained mental nurses. By 1956, it had 1,554 patients. With a high admission rate of patients aged over sixty-five years, it was, like other psychiatric hospitals, in danger of becoming a dumping ground for long-stay psychotic and psychogeriatric patients. In 1962, it had 1,489 beds. The farm had closed, but the orchard, bakery, butcher's shop and various workshops still provided occupation for the patients. By 1979, the bed numbers had decreased to 1,203, and to 952 by 1982. Bed numbers continued to decline as patients were rehabilitated and, in 1996, the long-stay beds closed. The hospital finally closed in 1997, but a small unit with sixty-seven beds, Horton Haven, opened on the edge of the site. Two outer villas were converted into a specialist rehabilitation unit.

*The site is now Livingstone Park. A few buildings have been converted to residences, but the rest demolished and new housing built. The Grade II listed chapel will eventually become a community centre.*

## St Ebba's Hospital
### Hook Road, Epsom, Surrey, KT19 8QJ

The Ewell Epileptic Colony opened in 1903, the LCC's first such institution. It accommodated 326 patients, sixty of whom were female, in eight one-storey villas widely spaced around the site and named after trees. Each housed thirty-eight patients and was staffed by a resident married couple. All the buildings had electricity. A large hall was used for dining and recreation, and also served as a chapel. Those physically able were expected to assemble for dinner in the hall, but other meals were taken in their wards. The patients worked on the farm, in the kitchens and laundry, and in the grounds. In the workshops they manufactured simple products. They received regular treatment, including bromide of strontium, and a specially regulated diet. In 1909, two more villas were built, and the number of patients increased to 429. In 1918, after the First World War, the site became the Ewell War Hospital, administered by the Ministry of Pensions, treating neurasthenic ex-servicemen until 1927, when it was returned to the LCC. It then became the Ewell Mental Hospital, and was extended in 1936 to 528 beds, and again in 1938 to 933 beds, when it was renamed St Ebba's Hospital.

In 1948, it joined the NHS with 738 beds. In 1949, an Adolescent Unit was established. By this time, some 95–97 per cent of its patients were voluntary. Psychological and Occupational Therapy Departments opened. Although patients still worked, their occupational backgrounds had changed. No longer unskilled paupers used to manual labour, they tended to be educated with clerical jobs; the workshops declined as the potential workforce preferred educational or cultural activities. In 1962, when it had 865 beds, the wards were converted for patients from the Fountain Hospital (*see p. 105*), then closing. It then had 470 beds – 183 for the mentally ill (later transferred to other hospitals) and 287 for the mentally handicapped. In 1969, an Industrial Training Unit opened and, in 1971, a Cement Products Department (making paving slabs in a variety of sizes and colour). By 1979, the hospital had 629 beds, but patients continued to be rehoused in community homes and, by 1995, there were 484 beds. In 2003, a Parents and Relatives Group launched a final campaign to save St Ebba's, but failed. The following year some of the buildings were converted and upgraded for fifty-five long-stay patients. The purpose-built oasis therapy suite and hydrotherapy pool opened in 2008 and is now run by the Surrey and Borders NHS Foundation Trust. South Lodge, a mental health centre for juveniles, is still active.

*The hospital remains officially open, although most of its services have closed or been relocated. The Grade II listed administration building and the water tower remain. The derelict villas have been demolished. New housing has been built and the site is now known as Parkviews.*

Fig. 130: One of the refurbished villas still in use.

## Long Grove Hospital
### Horton Lane, Epsom, Surrey, KT19 8PU

Named after a nearby area of woodland, Long Grove Asylum opened in 1907 with 2,000 beds. Regarded as a showpiece, it attracted excellent medical staff. Such was the demand for accommodation that, by 1911, there were 2,127 patients. The hospital was unusual in that it accepted typhoid carriers. These women, through no fault of their own, were capable of passing on typhoid and so were kept isolated from the main population (until antibiotics were developed there was no cure). In 1918, it was renamed Long Grove Mental Hospital (the word 'mental' was dropped in 1937). In 1943, a large number of Polish servicemen suffering from neurasthenia were admitted.

In 1948, the hospital joined the NHS. It had 2,163 patients, but staff shortages resulted in many wards remaining closed. The Polish patients (some 300) had become chronically mentally ill and their return to Poland was remote. A Polish interpreter was employed full-time and a Polish priest sometimes celebrated Mass. Polish concerts were held and ladies from the Anglo-Polish Society visited. By 1960, the hospital enjoyed an international reputation for being one of the most advanced and pioneering psychiatric hospitals. In 1971, it had 1,625 beds, reduced by 1979 to 1,183. Following the government's policy of 'Care in the Community', the hospital continued to be run down and, by 1985, had only 750 beds. It finally closed in 1992. Two typhoid carriers were found still living there, four decades after antibiotics for the infection had become available.

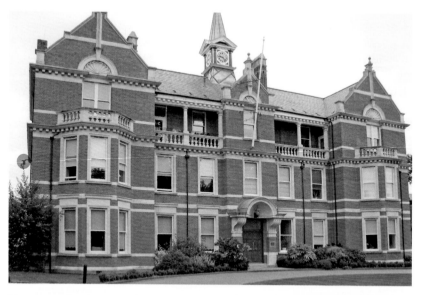

Fig. 131: The former administration building, now an apartment block – Prospect House.

*The site was redeveloped for housing in 1998 and completed in 2002. It is now called Clarendon Park. Most of the buildings were demolished, but a few hospital buildings remain. Many of the open spaces and trees have been retained.*

# West Park Hospital
## Horton Lane, Epsom, Surrey, KT19 8PB

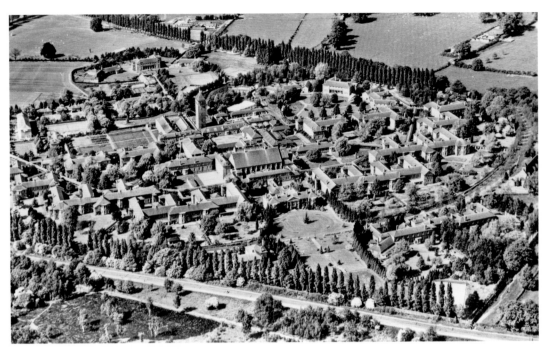

Fig. 132: An aerial view of the hospital shows its extent.

The West Park Asylum was the fifth and last of the Epsom cluster to be built. It was the first 'colony' asylum in England, with wards grouped together within the same building, creating separate communities. It had been due to open in 1916, but the work was delayed because of the First World War. The main buildings were completed in 1917, but then handed over to the Canadian army as a military hospital. The LCC received them back in 1921, and the asylum opened with 1,732 beds. It was finally completed in 1924, bringing the bed capacity to 2,000. In 1929, it was renamed the West Park Mental Hospital (the word 'mental' was later dropped from its name).

In 1948, it joined the NHS with 2,174 beds. In 1950, it had 2,545 beds. By 1971, there were 1,724 beds (39 per cent of patients slept in dormitories with fifty beds). By 1975 there were 1,600 beds and, by 1979, 1,217. The New Epsom and Ewell Community Hospital opened on part of the site in 1990. From the mid-1990s, the hospital was slowly emptied of patients as the policy of 'Care in the Community' progressed. It closed in 2002.

*The site was sold in 2003. The administration building and some of the ward blocks have been converted into dwellings. The Grade II listed water tower also survives. The remainder of the site has been developed as Noble Park, a new housing estate that opened in July 2009.*

# Goodmayes Hospital
Barley Lane, Goodmayes, Ilford, Essex, IG3 8XJ

Fig. 133: The central administration block was flanked by ward pavilions – male patients on the west side and female on the east.

The West Ham Borough Asylum opened in 1901 with 800 beds. A chapel, which could seat 600 people, opened the following year. In 1908, a neighbouring property was purchased and became Little Heath House, accommodating seventy female patients. In 1918, the asylum was renamed the West Ham Mental Hospital. New villas opened in 1934, increasing the bed complement to 1,300. During the Second World War, four wards became an Emergency Base Hospital. Geographically along a major route for enemy bombers heading towards London, several bombs fell nearby and one of the villas was destroyed.

The hospital joined the NHS in 1948 with 1,178 beds. It was renamed Goodmayes Hospital. Its farm closed, but an Industrial Therapy Unit was established to rehabilitate institutionalised patients, so they could acquire work discipline and eventually be discharged. By 1956, the hospital had 1,356 beds, but with new drug treatments the need for inpatient care lessened. In January 1969, a psychogeriatric unit opened. In the mid-1970s, the Brookside Unit was built to provide psychiatric care for adolescents. In 1975, the hospital had 1,087 beds but, by 1982, this had reduced to 781. The 1930s villas were demolished and the new King George Hospital (*see p. 77*) built on their site, opening in 1993. By 1996, the hospital had 273 beds. In 2001, Meadow Court opened, a nursing home with seventy beds managed by a health care provider independent of the NHS. In 2002, Chapters House with 107 beds was completed. In 2011, Sunflowers Court opened, a mental health facility with ninety-one beds to replace the existing patient accommodation.

*The hospital now consists of Chapters House and Sunflowers Court. The site of the chapel is now a car park. The redundant buildings will probably be sold for housing redevelopment.*

Fig. 134: The hospital was built in the north-west corner of the grounds of Friern Hospital at some distance from the main blocks.

Halliwick Hospital opened in 1958 with 145 beds, as the admission unit for Friern Hospital (*see p. 23*). It had been built in line with recommendations of the Mental Treatment Act 1930 – that every mental hospital should have a unit for 'recent cases' completely separate from the main building that housed (certified) patients of confirmed mental disorders.

Within a few years it began to change its ethos, becoming a psychiatric unit in its own right. Unlike Friern Hospital, it had no district responsibilities and its patients could be selected by the medical staff. Generously staffed in comparison to the hospital, it attracted the 'cream' of both staff and patients. Resources began to be diverted away from the 2,000 long-stay patients in the main wards, i.e. those who had the greatest need of them. Halliwick Hospital became a 'neurosis unit' for the less sick, socially superior and fringe patients. The main method of treatment was group therapy; art therapy was introduced in the 1960s.

However, by 1972, it had ceased to be a separate hospital and had reverted to its original purpose. By 1974, it was known as Halliwick House and had 130 beds for newly admitted patients and for those convalescing from the main hospital. It closed in 1993 when Friern Hospital closed.

*The hospital has been demolished and the site is now occupied by new housing.*

The Metropolitan District Asylum for Chronic Imbeciles opened in 1870. By October 1871, it had 899 female and 739 male patients (the sexes were strictly segregated) in accommodation designed for 1,500; ward storerooms had to be converted into bedrooms. Smoking was encouraged, being considered 'absolutely necessary to the treatment of the insane'. Visitors were permitted, but the journey from London was long and expensive, and proved an effective deterrent. By 1876, there were 2,118 patients. Additional ward blocks were built, but overcrowding was only temporarily relieved. In 1920, when it had 2,209 beds, it was renamed the Leavesden Mental Hospital. In 1930, the LCC took it over. Mains electricity was installed in 1931.

In 1948, it joined the NHS as a hospital for both the mentally ill and mentally handicapped, because of the acute shortage of beds. By 1950, it was again a hospital for the mentally handicapped, with 2,056 beds. Training schemes for young adults were developed to prepare them for local employment. In 1972, a Medium Secure Unit was opened, one of the first in a hospital. By 1974, patient numbers were falling and the hospital had 1,356 beds (850 by 1990). The pace of resettlement into the community continued and it closed in 1995 with 189 beds.

*Most of the buildings were demolished, but the administration block, the chapel and the recreation hall remain. The site has been redeveloped for housing. The grounds are now part of Leavesden Park.*

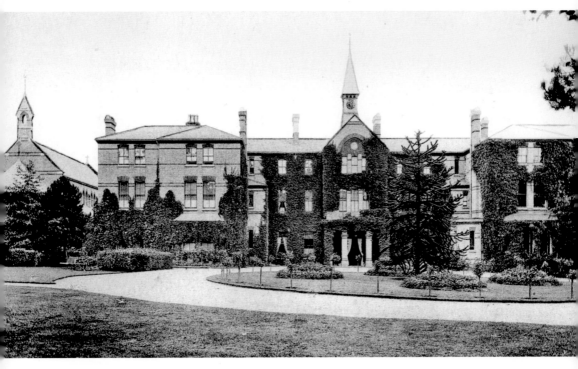

Fig. 135: The asylum was built by the Metropolitan Asylums Board on a 143-acre site, purchased in November 1867 for £7,600.

Fig. 136: Male attendants in a ward decorated for Christmas.

# Places to Visit and Further Reading

Much information on hospitals in London can be found at:

London Metropolitan Archives,
40 Northampton Road,
Clerkenwell,
London EC1R oHB

Wellcome Library,
183 Euston Road,
London NW1 2BE

This book gives an overall view of the development of hospitals within the UK:

Barry, G., L. A. Carruthers, *A History of Britain's Hospitals* (Sussex, Book Guild Publishing, 2005)

For information about the hospitals of central London, this could not be bettered:

Black, N., *Walking London's Medical History* (London, Royal Society of Medicine Press, 2006)

For an up-to-date, comprehensive and detailed outline of the NHS from its beginnings in 1948 see:

www.nhshistory.net

This useful website gives great detail about workhouses, their history, their infirmaries (from which many NHS hospitals were derived) and other information about the Metropolitan Asylums Board:

www.workhouses.org.uk

# Index